ANTHONY FRIEDKIN

THE GAY ESSAY

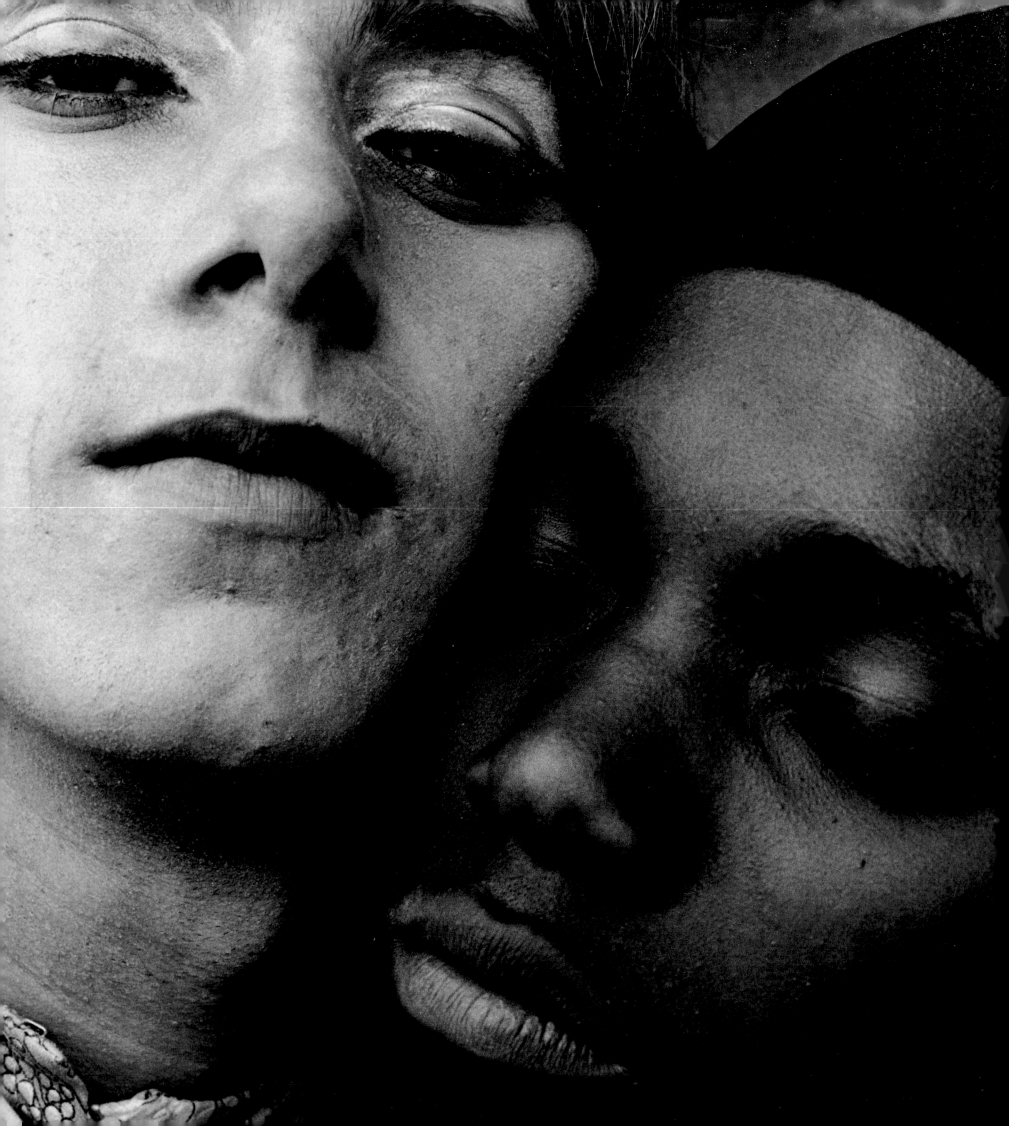

ANTHONY FRIEDKIN

THE GAY ESSAY

JULIAN COX

WITH NAYLAND BLAKE AND EILEEN MYLES

FINE ARTS MUSEUMS OF SAN FRANCISCO

PUBLISHED IN ASSOCIATION WITH

YALE UNIVERSITY PRESS, NEW HAVEN AND LONDON

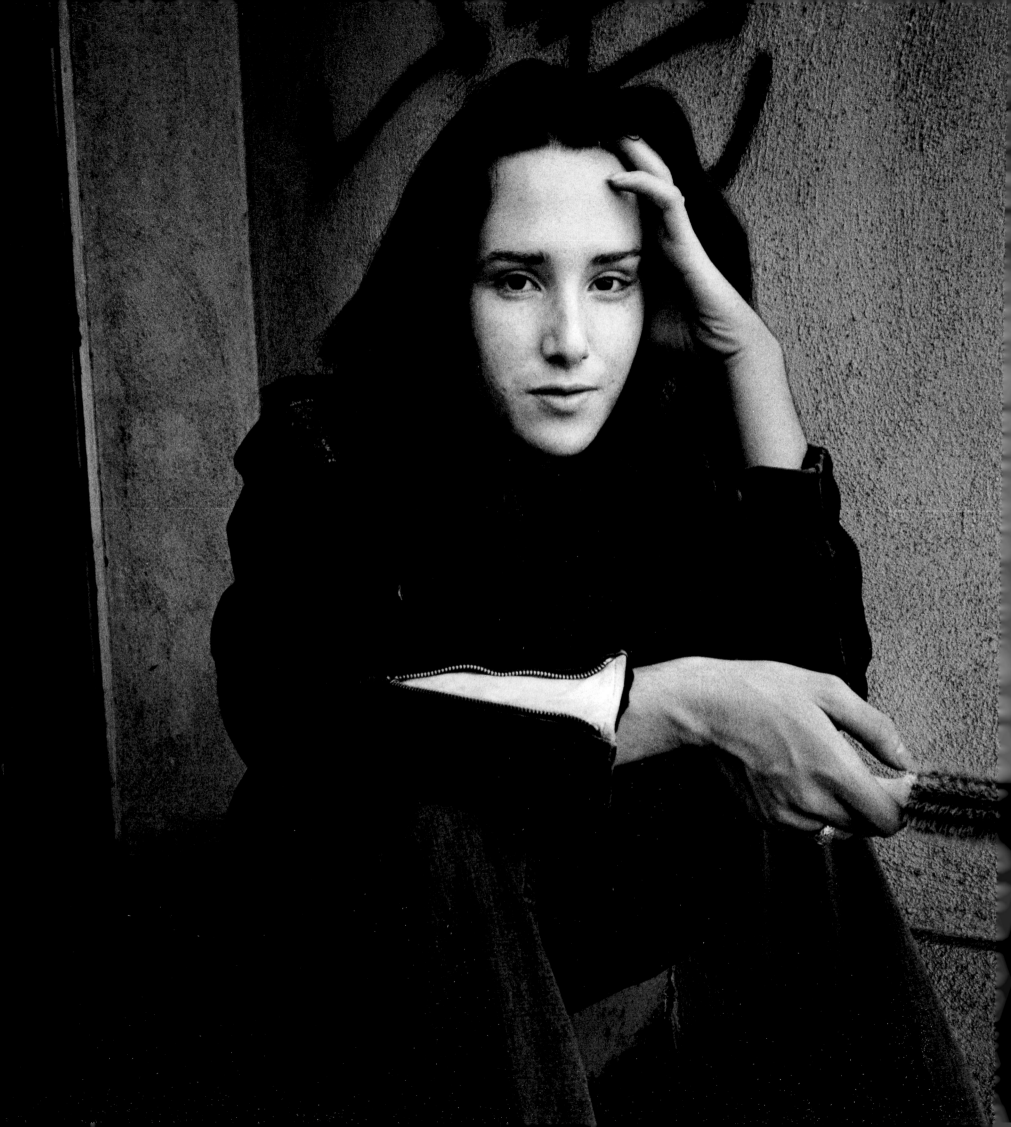

CONTENTS

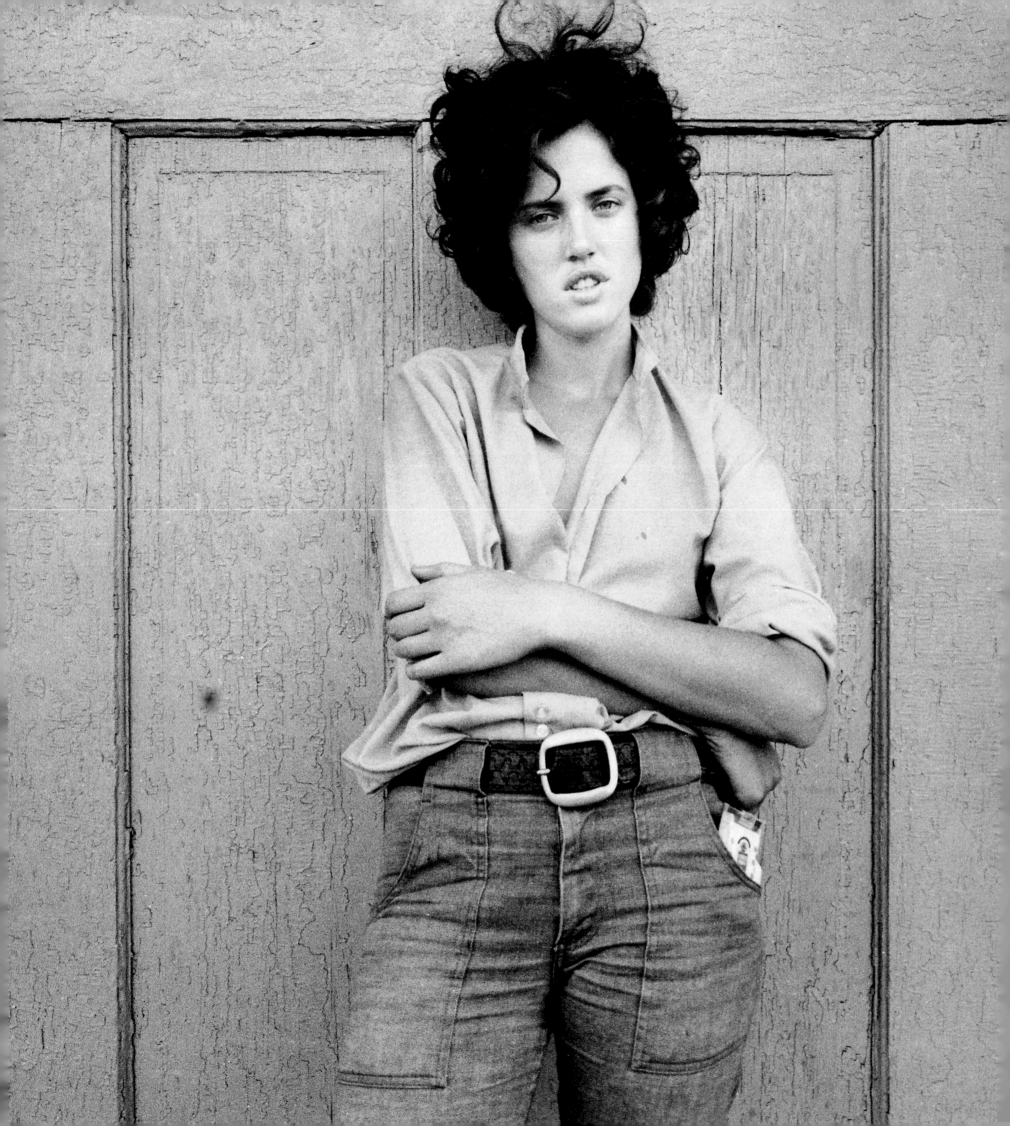

FOREWORD

THE FINE ARTS MUSEUMS of San Francisco are honored to present the exhibition and publication *Anthony Friedkin: The Gay Essay*, devoted to a series of photographs made between 1969 and 1973, at the outset of the photographer Anthony Friedkin's long and productive career. *The Gay Essay* is a kaleidoscopic, personal response to gay life in Los Angeles and San Francisco at the dawn of the Gay Liberation movement. More than four decades later, it stands as both a significant record of historic change in our culture and an eloquent testament to Friedkin's passion for the art of photography.

The exhibition is installed at the de Young, a museum that has established an increased presence for photography in recent years, with the goal of bringing to light important, and sometimes neglected or overlooked, bodies of work that enrich the history and study of a medium that is central to art and society today. *The Gay Essay* is exhibited here in its full depth for the first time, within a historical and critical framework provided by Julian Cox, our founding curator of photography and chief administrative curator. The catalogue has been written and produced in collaboration with the photographer, as well as with the artist and educator Nayland Blake and the poet and writer Eileen Myles.

We are deeply indebted to Anthony Friedkin for allowing Julian Cox such generous access to his archives to make the selection of photographs for the exhibition and its catalogue. We are proud that ninety-four vintage prints from *The Gay Essay* are now part of our permanent collection, thanks to the generosity of donors Mary and Dan Solomon, who recognized the importance of this work and have made substantial gifts over successive years. The Solomons were joined in this effort by Nancy Ascher and John Roberts; thanks to their support, the Fine Arts Museums can boast the finest holdings of Friedkin's work in any American museum. We are further grateful for the Museums' Andrew W. Mellon Foundation Endowment for Publications, which has made this catalogue possible.

Colin B. Bailey
Director of Museums
Fine Arts Museums of San Francisco

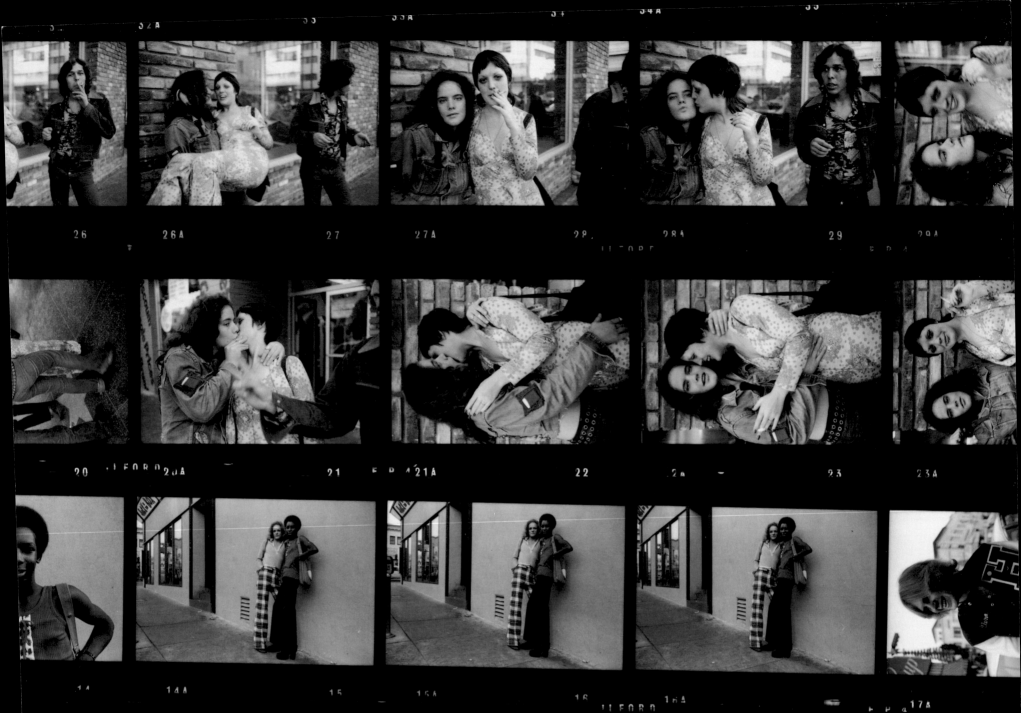

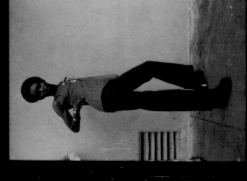
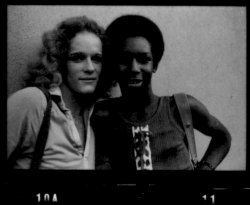

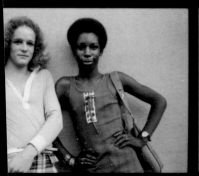
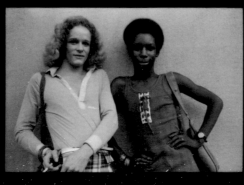
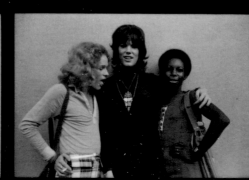
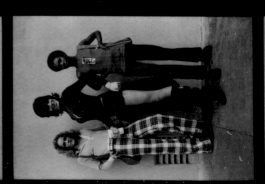

BEHIND THE VEIL
REFLECTIONS ON *THE GAY ESSAY*

IN THE SPRING of 1969, Anthony Friedkin (American, born 1949) was an athletic, zealous youth of nineteen. A native of Los Angeles and a gifted surfer, he was studying photography at the Art Center College of Design, and decided to head to Europe for the summer. He teamed up with two friends, and they pooled their resources to purchase a Volkswagen bus to tour the continent from July through September.[1] Friedkin's carefree adventures could not have been in starker contrast to the series of escalating confrontations that took place in the streets of Greenwich Village, New York, on the eve of his departure. On June 28, a bevy of officers from the Manhattan vice squad entered the Stonewall Inn—a Mafia-owned, money-gouging tavern on Christopher Street frequented by gays—allegedly to discuss the unlicensed nature of the business. After a series of heated exchanges, the customers filed outside and surrounded the police and the bar's owners, barricading them inside and launching a rain of improvised Molotov cocktails, rocks, and broken street furniture through the windows of the premises. The riot was followed by three days of civil unrest, during which more than thirty people were injured. Despite the mayhem and costly property damage, this show of public defiance brought pride to homosexual communities across the country. Stonewall was widely acknowledged as the pivotal, pioneering act of the Gay Liberation Movement.[2]

In 1969, homosexual acts were illegal in every state except Illinois. Gays and lesbians were not protected by law or the Constitution, and they were barred from serving in the federal government. In Los Angeles, under the direction of gay liberation pioneer W. Dorr Legg,[3] the Institute for the Study of Human Resources published the pamphlet "Homosexuality—25 Questions & Answers" to "replace misconceptions and fears about homosexuality with a better understanding of the subject. It is hoped that this will result in improved and more humane attitudes toward those men and women for whom homosexuality is their way of life and to effect a better integration into society of such individuals . . . such a goal would seem to be preferable to the traditional practice of alienating them."[4] The simmering tensions between increasing public expressions of gay life and the reactionary desire to maintain social control was the subject of a groundbreaking two-part story, titled

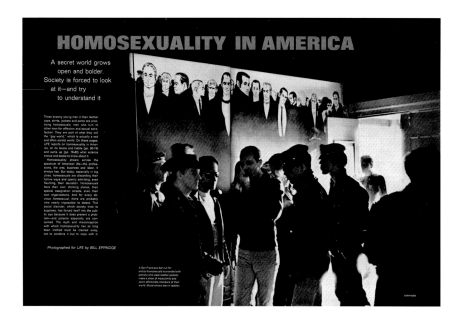

"Homosexuality in America," published in *Life* magazine in 1964.[5] Appearing in a weekly news source that reached a national audience of more than eight million readers, the story is illustrated with photographs by Bill Eppridge, including his shadowy opening image of leather-clad men gathering at the Tool Box, a bar at Fourth and Harrison streets in the South of Market district of San Francisco (fig. 1). Journalist Paul Welch described California as a haven for gay life because of its "reputation for easy hospitality," adding that "as homosexuals become more visible to the public, there is a real need for greater knowledge about them."[6] The writer identified anxiety within the gay community and widespread ignorance among the general public as a pervasive reality: "Homosexuals everywhere fear arrest—and the public exposure that may go with it. In Los Angeles, where homosexuals are particularly apparent on city streets, police drives are regular and relentless. . . . and for every obvious homosexual, there are probably nine nearby impossible to detect. This social disorder, which society tries to suppress, has forced itself into the public eye because it does present a problem—and parents especially are concerned."[7] The eruption that was Stonewall was the inevitable consequence of a rising tide of intolerance within mainstream society and its blind indifference to the steadily growing assertiveness of the gay community. The closet doors were blown open.

STARTING OUT

Anthony Friedkin was taking photographs at the age of eight and by eleven was developing his film in the darkroom. When he graduated from University High School in 1967, he had reached advanced proficiency with a camera and was adept at a variety of technical and darkroom procedures. He felt deeply connected to the medium and recognized its potential as a vocation. Aside from his public schooling, Friedkin's disposition toward the arts and inclination to pursue a life as an artist came from his immediate family. His mother, Audrey, from upstate

New York, was an accomplished dancer who performed extensively on Broadway before she moved to the West Coast, and his father, David, was a successful screenwriter and director in Hollywood.[8] The Friedkins had a passion for the visual arts, collecting prints, works on paper, and art books.[9] The family was also attuned to social issues, with debate encouraged at mealtimes and family gatherings. They regularly entertained and counted as close friends a gay male couple, one of whom was a dancer at Paramount Studios. The couple visited often, and Friedkin remembers them as warm, funny, and extremely intelligent.[10] Amid this vibrant, highly sociable home life, Friedkin developed an outgoing personality and an avid curiosity that fueled his outlook as a photographer.

After high school, Friedkin studied photography at the Art Center College of Design and the University of California, Los Angeles, where he took classes with Robert Heinecken and Edmund Teske.[11] He also worked independently under the guidance of Todd Walker, whom he considers his most important influence and primary mentor. While Heinecken's and Teske's conceptual and experimental investigations intrigued him, their explorations did not coincide with his own approach to the medium, which was purist, traditional, and personal. Friedkin sought to combine the accuracy and specificity of the photojournalistic tradition with an individual statement. His search for truth was imperative, as was his commitment to a self-assigned form of reporting that tackled social issues from an experiential point of view. For half a century—from Henri Cartier-Bresson to Robert Frank to Garry Winogrand—the theater of public life and the city street was favored by photographers, offering a plethora of incidents and characters and seemingly limitless artistic possibilities. This was to be Friedkin's stage, and capturing the "human spirit and how that spirit manifests itself" his foremost aesthetic challenge.[12]

To guide his way, Friedkin read closely Cornell Capa's *The Concerned Photographer*, which Capa had written in 1968 after establishing a fund for socially committed photography. Through this fund, which would lead to his further founding of the International Center of Photography, New York, in 1974, Capa sought to keep independent humanitarian photography visible and relevant. His intentions were outlined in the introduction to *The Concerned Photographer*: "The Fund is dedicated to the recognition of photography as a very personal means of communication, to the recognition of the photographer as an individual with his very own, recognizable graphic style and human content who translates what he sees into frozen reality. The resulting images bear the photographer's own respect for truth."[13] Friedkin found his place in a like-minded approach that retained the outward-looking spirit of reportage, but he sidestepped the more homogenized vocabulary of photojournalism, striving to record the world in a way that privileged individual discovery and utilized photography's capacity for social agency.

Magnum Photos, cofounded in 1947 by Robert Capa (Cornell's brother) as a cooperative that supported an independent approach to documentary practice,

Fig. 1. "Homosexuality in America"
Life 56, no. 26 (June 26, 1964)
Photograph by Bill Eppridge

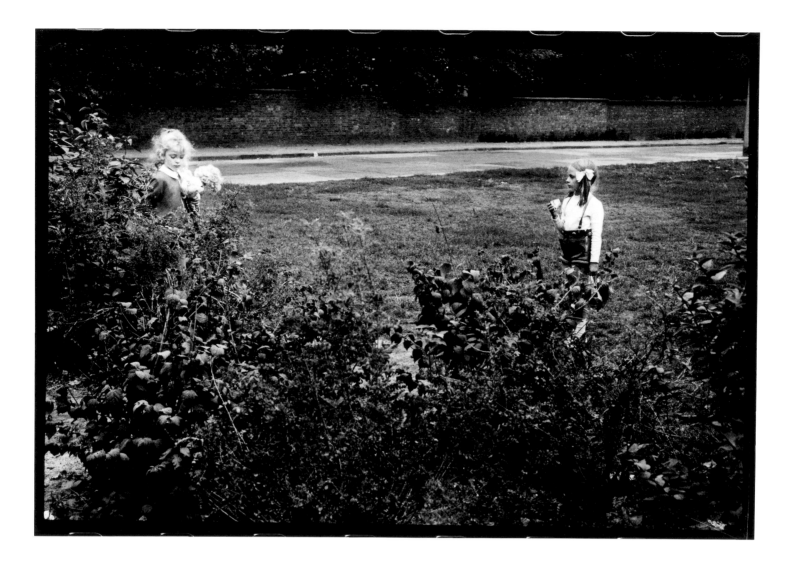

played a pivotal role in Friedkin's artistic evolution. Magnum's operating principle of maintaining control over the selection and management of photographic assignments (as well as the archiving of negatives, prints, and image copyrights) allowed for an autonomy that was compelling for a generation of photographers who wanted to combine their skills as reporters and artists with the freedom to pursue projects of their own choosing.[14] Friedkin visited the Magnum offices in New York City for the first time in the fall of 1969, shortly after his return from Europe, and he shared a portfolio of images from his travels.[15] Among them was an undemonstrative but deeply affecting picture of two young girls standing in a field by a roadside on the outskirts of East Berlin (fig. 2).[16] There is a distant and still quality to the composition. The girls inhabit a space behind a proscenium-like thicket of bushes that hems them in and separates their world from ours. While the center of the scene is vacant and empty, it is intangibly furnished by the imaginative play of the children and their seemingly silent communication. This may appear to be a chance encounter, with nothing to suggest that the photographer has tampered with the purity of the scene as found, but there is an air of mystery that disrupts the otherwise unmediated quality of this image of everyday life.

Friedkin's cinematic approach hints at narrative, inviting the viewer to engage his subjects as credible and realized characters in a picture-story. Magnum photographer Charles Harbutt found Friedkin's European pictures "powerful and direct," adding, "How great he becomes all depends on the depth of understanding that he reaches inside of himself and of his world."[17]

On that first trip to New York, Friedkin made repeated visits to the Magnum offices to meet with some of the agency's photographers and assignment editors, but mostly to spend time poring over notebooks of contact sheets. He was thrilled to see the working processes of Henri Cartier-Bresson, David Seymour, and George Rodger laid bare through their contact sheets, and he marveled at the discoveries he made in notebook after notebook of images.[18] Magnum suggested that Friedkin join the agency and move to New York, but he preferred to remain in California, where he could surf and where he believed ample opportunities existed for a career in photography. He then was invited to work as a stringer for Magnum in California, which he did, but he remained a freelancer, stopping short of taking up full membership in the organization, which would have required him to be voted in by an existing member after submitting to a rigorous program

Fig. 2. Anthony Friedkin, *Two Girls in Berlin*, 1969
Gelatin silver print, 11 × 14 in. (27.9 × 35.6 cm)
Collection of the artist

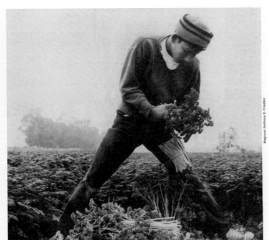

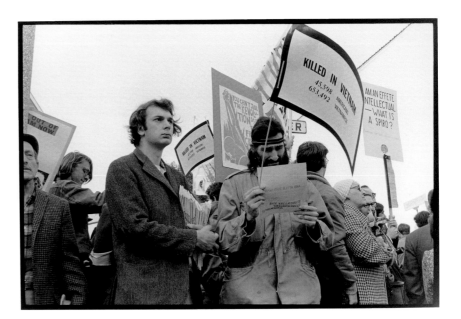

of portfolio reviews. Occasionally, his pictures were reproduced in print with a Magnum credit. His 1972 photograph of a boy picking parsley, made in Oxnard, California, ran as the centerpiece image in a story titled "Harvest of Hunger," about America's migrant farmworkers (fig. 3). Although he retained a polite distance from Magnum most of the time, preferring to pursue self-assigned projects, Friedkin employed the philosophy of its participating photographers, who were united by "a shared human quality, a curiosity for what is going on in the world, and a desire to transcribe it visually."[19]

It was something of the Magnum spirit that led Friedkin to respond to the call for a moratorium against the Vietnam War. In the frigid fall of 1969, more than 500,000 people marched on Washington to protest US involvement in Vietnam. The November rallies were part of a string of demonstrations taking place around the country, including San Francisco and Berkeley. Friedkin's older brother, Gregory, was an undergraduate at UC Berkeley at the time, so Friedkin traveled north to visit him and took the opportunity to photograph the gatherings in Golden Gate Park and Berkeley on November 15, 1969 (fig. 4).

Before he fully turned to creating *The Gay Essay*, Friedkin was working within a tradition that was already well established among more celebrated contemporary photographers. The unflinching truths of Diane Arbus's imagery dominated the 1967 *New Documents* exhibition at the Museum of Modern Art, New York, where her work was shown alongside the torqued street photographs of Garry Winogrand and the laconic and witty urban landscapes of Lee Friedlander. The curator, John Szarkowski, stated, "[A] new generation of photographers has directed the documentary approach toward more personal ends. . . . Their aim has been not to reform life, but to know it."[20] While the distinctively personal visions of Arbus, Winogrand, and Friedlander resonated with him, Friedkin felt more kinship with W. Eugene Smith, who was prominently featured in *The Family of Man* and whose photo essays were widely reproduced in contemporary magazines

and journals.[21] Smith's firebrand approach and his flair for the photo-story proved inspirational, as did the work of Danny Lyon, who had photographed members of the Outlaws motorcycle gang in depth and generated from that project his seminal 1968 book, *The Bikeriders*.[22] Friedkin admired Lyon's complete authorial control of his content, which combined his photographs with his own text in an innovative way and rendered his vision with a richness that outstripped the typical magazine-length story.[23]

CAPTURING COMMUNITY

Anthony Friedkin embarked on *The Gay Essay* as a completely self-assigned project. Friedkin sought to create the first extensive record of gay life in Los Angeles and San Francisco in an attempt to chart the emerging and shifting visibility of the gay community in California.[24] His goal was not to be comprehensive in his documentation, but rather to conjure its spiritual and emotional core through photography. He was most interested in men and women who were trying to live openly, expressing their sexuality and a burgeoning sense of personal freedom, and improvising ways to change the culture.

The hub for Friedkin's exploration of this populace was the Los Angeles Gay Community Services Center, in a residential neighborhood west of downtown Los Angeles (fig. 5). Its program was run by Morris Kight and Don Kilhefner, activists who had founded the Gay Liberation Front of Los Angeles in December 1969, within six months of the Stonewall riots. A dynamic pairing, Kight was vice president of the center and Kilhefner its executive director. While other gay organizations had preceded theirs in the city, Kight and Kilhefner were among the most progressive thinkers in LA. Primarily but not exclusively devoted to the welfare and concerns of the gay male population, their activism was a collaborative process, bringing volunteers and community leaders together to make change at a grassroots level and beyond.

Fig. 3. "Harvest of Hunger"
Good Housekeeping, September 1972
Photograph by Anthony Friedkin

Fig. 4. Anthony Friedkin, *Vietnam Moratorium Protest,*
San Francisco, November 15, 1969
Gelatin silver print, 8 × 10 in. (20.3 × 25.4 cm)
Collection of the artist

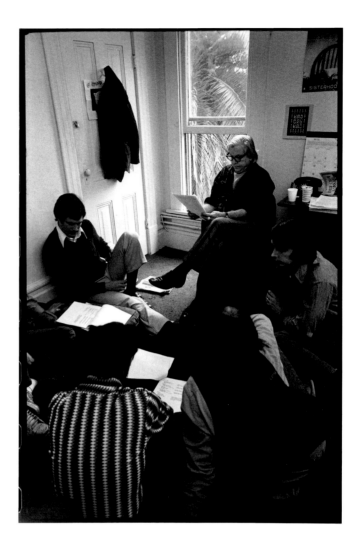

Kilhefner was the guiding force behind the Gay Liberation Front's Survival Committee, staffed by volunteers, which provided free services specifically geared to the needs of the gay community: legal advice, draft counseling for gay men, and help for those with sexually transmitted diseases and drug problems. In an article for the *Los Angeles Free Press*, Kilhefner described the genesis of their work: "To a large extent, the Gay Survival Committee is an outgrowth of the current intensification of the LAPD's continuous program against homosexuals in this city. During this past year three gays were killed by the police. Police harassment, entrapment and brutality is a daily fact of life in the gay community." Kilhefner's article goes on to describe some of the services offered, tailored to community needs: "Informal personal liberation rap sessions are also being designed for younger gays who are dealing with the 'coming out' process as well as discussion groups for gays seeking an alternative to the present dehumanizing bar and bath scene" (fig. 6).[25] Friedkin documented many of these activities as a natural outgrowth of his ties to Kilhefner and Kight and his sympathy for their objectives. While these photographs were never exhibited or published as part of *The Gay Essay*, they underscore Friedkin's deep engagement with his subject and his desire to give a thorough accounting of the gay community, its system of

organizing, and its quest for integration. The mutual trust and respect between the photographer and these twinned community leaders is apparent in Friedkin's picture of the couple (pl. 44). It is a hopeful, tender, and joyful portrait that vividly captures the bonds of respect and love between these two men.

It was this alliance with Kight and Kilhefner that provided Friedkin an entry into the gay world that would not ordinarily have been part of his experience. Every Friday night, Kight and Kilhefner organized a gay dance at Trouper's Hall, on La Brea Avenue just south of Hollywood Boulevard and in close proximity to the Gay Community Services Center. The weekly dance provided a meeting place for youth who were dipping their toes into a new way of life. Kight explained it thus: "Here were young men and women, eighteen, nineteen, and twenty, who suddenly and often painfully cast off heterosexual assumptions and went through a period of discovery."[26] Friedkin photographed the dances extensively (see pls. 1–7), making his best pictures in the club's parlor room, where he observed furtive moments of flickering psychological interplay between freshly minted couples. There is a sense of incipient drama in these photographs, which are like suspended moments in a delicately unfolding narrative. Barely beyond the teenage years himself, Friedkin identified with his peers and recognized their quests for

Fig. 5. Anthony Friedkin, *Morris Kight and Don Kilhefner and Volunteers at the Gay Community Services Center, Los Angeles*, ca. 1970–1972
Gelatin silver print, 10 × 8 in. (25.4 × 20.3 cm)
Collection of the artist

Fig. 6. Anthony Friedkin, *Morris Kight Leading a Workshop at the Gay Community Services Center*, ca. 1970–1972
Gelatin silver print, 10 × 8 in. (25.4 × 20.3 cm)
Collection of the artist

he labored for hours to create prints of the highest quality, coaxing his 35mm negatives to deliver results that he intended to equal those made from larger-format films preferred by such heralded figures as Ansel Adams and Edward Weston.

ACTIVISM AND DISPLAY

The specter of politics and the demonstrated power of personal activism are important components of *The Gay Essay*. Social change was never far from Friedkin's mind, and he was drawn to activists in the Los Angeles community who were committed to making a difference in gay lives. Foremost among them in the early 1970s was Reverend Troy Perry, a Pentecostal minister who had left his wife and two children and a successful ministry in Minnesota to move west to Los Angeles when he acknowledged his long-repressed sexuality.[27] Hailing from a family of preachers in north Florida, Perry had heard the call to the ministry as a teenager and had actively subscribed to the Christian gospel all his life. He was convinced of God's love for all people, and he founded the Metropolitan Community Church (MCC) in the fall of 1968 on this principle. The MCC was a Christian church that provided an affirming ministry for the gay, lesbian, bisexual, and transgender communities. Perry had a clear plan for people who had been ousted from religious groups. Many of his early congregants were defrocked clergymen like himself. His MCC met weekly in south Los Angeles. Within two years, more than a thousand people attended his services, and branch churches spawned in cities across the country.

Friedkin photographed Perry and the activities of the MCC extensively, usually immediately following the Sunday-morning service.[28] Interracial couples abound in his images, casually posed against the stucco walls of the church exterior (see pls. 45 and 46). One morning he showed particular interest in a congregant who brandished a copy of the November 1972 edition of *Lesbian Tide*, the most journalistically advanced lesbian publication of the day, featuring a cover story on Gloria Steinem (fig. 8). But perhaps no picture in *The Gay Essay* better illustrates the repositioning of gay rights from social oblivion to the moral high ground than does Friedkin's portrait of Reverend Perry standing defiantly in the charred ruins of his church, at 22nd and Union streets, which was badly damaged by fire on January 27, 1973 (pl. 40).[29] Perry's stoic bearing suggests that he would not be defeated by this course of events. The fire destroyed most of the church's roof and the ceiling of the main sanctuary, as well as Perry's office. Crucial financial documents were recovered, but the church was forced to relocate. Arson was suspected, but the city's fire department was unable to verify this at the conclusion of their investigation. Unbowed, Perry vowed to rebuild his church in another part of the city, and did so after moving to temporary premises at 6230 West Sunset Boulevard.[30]

One of the most significant outcomes of Stonewall was the birth of the gay-pride parade, which marked the first anniversary of the uprising. The initial parade was held in New York City in 1970, and its overwhelming success quickly

emotional connection and desires for acceptance—taking his viewers behind the curtain at Trouper's Hall and lifting the veil on a world of tentative self-discovery.

By nature charming and convivial, Friedkin was adept at moving among his subjects and alert to ways of framing a telling gesture or describing psychology through pose and expression. He worked almost exclusively with the 35mm Leica M4 camera, which was introduced in 1967, and which he received as a gift from his father (fig. 7). It is compact and highly portable, and Friedkin wielded it unobtrusively, imparting to his pictures both intimacy and immediacy. He used black-and-white film, and most exposures (especially those made indoors) were created under low-light conditions that often required him to push the exposure limits of the film. The lightweight Leica allowed him to operate without a flash and (most of the time) without a tripod. He could shoot at a shutter speed of an eighth or a quarter of a second, fast enough to record action behind the scenes at a club or onstage at a show. Produced on silver-rich Varilour VLTW paper manufactured by DuPont, Friedkin's prints have a dark, grainy quality, characterized by deep blacks and creamy highlights. He maintained careful control of the chemistry, sometimes adding a highly diluted mixture of water and selenium toner to enhance the intensity of the blacks and grays. A consummate technician,

Fig. 7. Anthony Friedkin, *Self-Portrait with Leica M4 Camera*, ca. 1970
Gelatin silver print, 10 × 8 in. (25.4 × 20.3 cm)
Collection of the artist

14

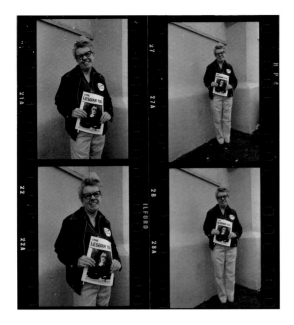

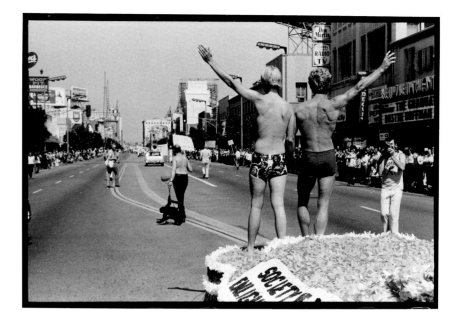

gave rise to other parades across the country. The prime movers in planning and executing the first Los Angeles parade, in the summer of 1970, were Perry and Kight. They called their gathering the Christopher Street West Parade. When they petitioned the city of Hollywood for a permit for the event, the Los Angeles chief of police, Edward M. Davis, openly remarked that he would rather have thieves and burglars marching in his town.[31] Perry and Kight worked with the American Civil Liberties Union to file a lawsuit, and the permit was granted just forty-eight hours before the event. Twelve hundred marchers came, and tens of thousands watched the spectacle on Hollywood Boulevard. It was the first gay parade to close the street.[32] Two years later, gay life on the city streets of Los Angeles started to look more fun than fearful (fig. 9). Friedkin photographed it in depth (pls. 8–14), and it became an integral part of *The Gay Essay*, demonstrating as it did the coexistence of camp theatricality (pls. 8, 9, and 12) and purposeful activism (pls. 10, 11, and 13).

The tender portraits of Jim Aguilar (pls. 66–71) are among the strongest photographs in *The Gay Essay*. Angelic and androgynous, Jim is singularly himself, but Friedkin's extended portrait of him seems to express symbolically the importance of intimate, lived experience. The inwardness of Jim, as subject, prompts reflection on the inner depths of our own lives. But there is also an undercurrent of anguish in Friedkin's portraits of Jim, about whom he writes: "I first met Jim at Trouper's Hall. For months thereafter we worked together and became close friends. Jim was raised in East Los Angeles, a community primarily Chicano and dangerously macho. It's not easy to be gay and live in East LA. Often his mother screamed at him, called him queer. He was afraid to walk the streets alone. Jim could have become an active barrio gang member and carried a knife or gun. But he only carries a brush for his hair."[33] Aguilar looks proud and confident in some pictures, and seems particularly happy to be posing with his friend Mundo in front of a hot dog stand in Montebello (pl. 68). But in others his eyes reveal a

loneliness and vulnerability that stand in stark contrast to the bold strokes of graffiti that frame his figure and signal something of the harshness of his immediate environment (pls. 66 and 71). The tenderness and affection that Friedkin shows for his subject presages the work of the Boston school of photographers—most notably Nan Goldin and David Armstrong—and their intimate portrait of gay life in Boston in the years (circa 1974–1980) immediately following the completion of *The Gay Essay*.[34]

While Friedkin certainly courted serendipity when photographing for *The Gay Essay*, it is the slow, measured accumulation of frames that marks out the work. In this way his approach has some affinity with the mechanics of Hollywood movies (which were well known to him, even as a young man), in which the camera operator might spend a whole day on location for the sake of a single shot. His contact sheets show that he was rigorous in his examination of a subject and alert, intently studying the sitter and location to identify the most satisfying composition. For example, a rugged, mustachioed hustler named Dan is observed and photographed at length in an anonymous, nondescript motel room. In one of three surviving contact sheets remaining from this encounter (fig. 10), it is clear that Friedkin moved very deliberately around the room, recording a variety of gestures and poses culminating in a sequence of full frontal close-ups that leave little doubt as to the subject's trade. In the dream factory that is Hollywood, the male hustler traffics in the business of fantasy.[35] He sells himself as a dream to others, even if the circumstances of his doing so might suggest a more prosaic outcome.

The seedier side of gay life in Hollywood was a fundamental component of *The Gay Essay*. Cruising and gay hustling became increasingly prevalent in the 1960s, with journalist Paul Welch stating in *Life* magazine: "In Hollywood, after the bars close for the night, Selma Avenue, which parallels Hollywood Boulevard, becomes a dark promenade for homosexuals. . . . In the shadows that

Fig. 8. Anthony Friedkin, *Woman Holding Copy of "Lesbian Tide" Magazine*, 1972
Gelatin silver print (contact sheet, detail), 8 × 10 in. (20.3 × 25.4 cm)
Collection of the artist

Fig. 9. Anthony Friedkin, *Gay Liberation Parade, Hollywood*, 1972
Gelatin silver print, 11 × 14 in. (27.9 × 35.6 cm)
Fine Arts Museums of San Francisco, anonymous gift, 2011.58.36

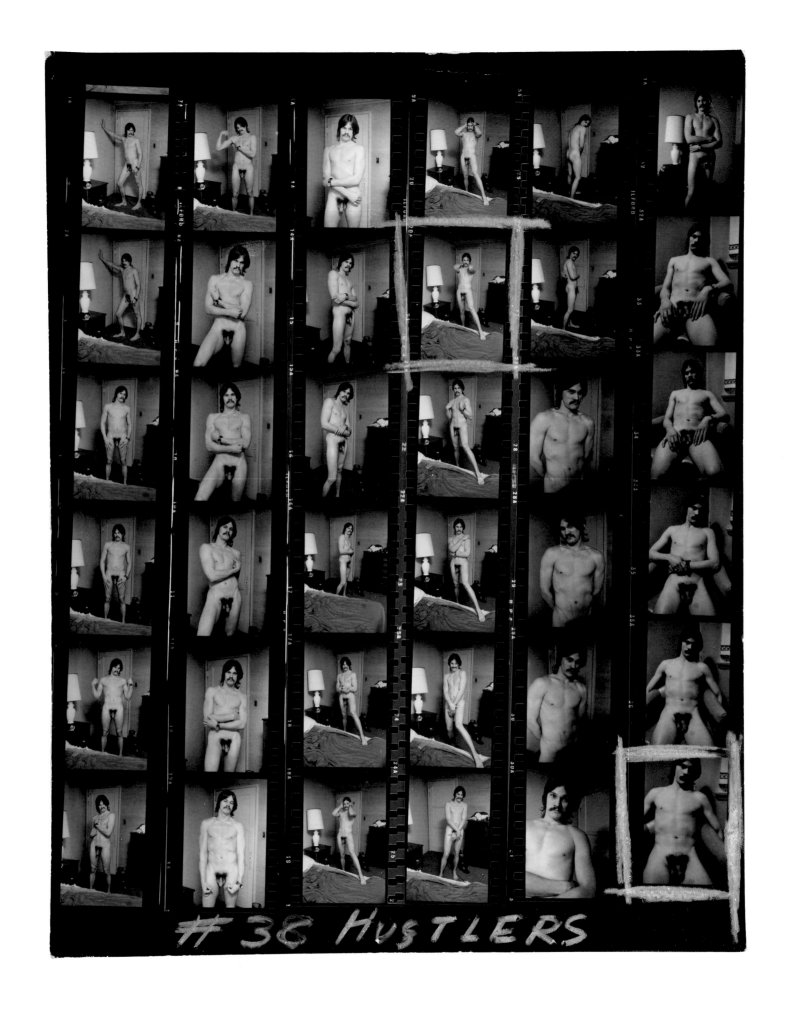

Fig. 10. Anthony Friedkin, *Dan, Hustler, Burbank*, 1972
Gelatin silver print (contact sheet), 10 × 8 in. (25.4 × 20.3 cm)
Collection of the artist

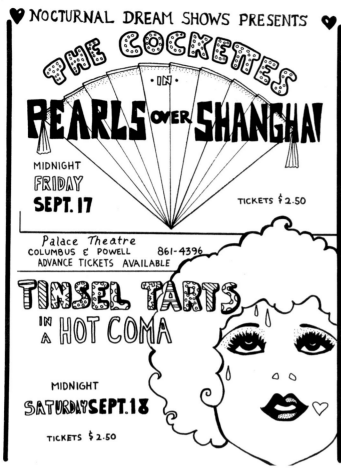

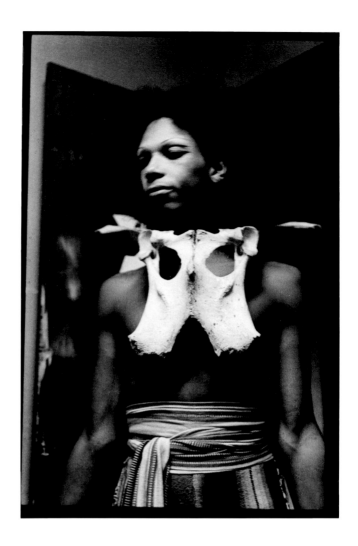

reach out beyond the streetlights, the vignette is repeated again and again until the last homosexual gives up for the night and goes home. . . . The running battle between police and homosexuals has produced bitter feelings on both sides."[36] The seedy gay male movie houses (pls. 17 and 18), wily hustlers looking for tricks (pls. 15 and 16), and tensions between male prostitutes and the vice police (pl. 20) are all visited in Friedkin's photographs, which were often shot late at night in fraught, dangerous circumstances. Among the most striking pictures in this part of the series are those that show the youth and vulnerability of scrawny runaway boys loitering in doorways, scanning the streets for prospects (pls. 21–22). Seeking to capture novel scenarios on film, Friedkin sometimes tailed the vice police up and down Hollywood and Selma boulevards. On one occasion, he was almost shot for approaching two officers who were in the midst of rousting two men out of the bushes to book them for indecent public exposure.[37]

THEATER IN SAN FRANCISCO

In the fall of 1972, when his work on *The Gay Essay* was beginning to draw to a close, Friedkin made a trip to San Francisco with the express intention of photographing the Cockettes, a gender-bending experimental theater troupe

that performed at the Palace Theater in North Beach.[38] Beginning in 1970, the Cockettes had wowed Bay Area audiences with improvised musicals and theatrical ditties that were a unique blend of high camp and over-the-top vaudeville. With stage names such as Goldie Glitters, Hibiscus, Pristine Condition (see pl. 59), Scrumbly, Rumi, Sylvester, and Big Daryl, their productions included *Madame Butterfly* (performed in fake Cantonese), *Pearls over Shanghai* (fig. 11), *Les Etoiles du Minuit*, *Journey to the Center of Uranus*, and *The Circus of Life*. The majority of the performers were hippies dressed in drag, and whether they were male or female, straight or gay, gender confusion was their modus operandi. They were fueled by drinks and drugs, LSD being preferred for its hallucinogenic properties. Film director John Waters, who introduced Divine (see pl. 62) to the Cockettes, described the troupe as "hippy-acid freak drag queens" devoted to sexual anarchy and living life at the height of their imaginations.[39]

When Friedkin headed to San Francisco in late October 1972, the Cockettes had technically disbanded. They had taken their talents to New York City in November 1971 and played a series of dates at the Anderson Theater in Greenwich Village. The shows were a disaster and the performances universally panned by critics. They were laughed out of town by Jackie Curtis, Candy Darling,

Fig. 11. *Pearls over Shanghai*, 1971
Playbill for concert performed by the Cockettes at the Palace Theater, San Francisco
Collection of the Gay, Lesbian, Bisexual, Transgender Historical Society, San Francisco

Fig. 12. Anthony Friedkin, *Sylvester, Backstage at the Palace Theater, San Francisco*, 1972 17
Gelatin silver print, 10 × 8 in. (25.4 × 20.3 cm)
Fine Arts Museums of San Francisco, anonymous gift in honor of
Sheila Glassman, 2012.70.26

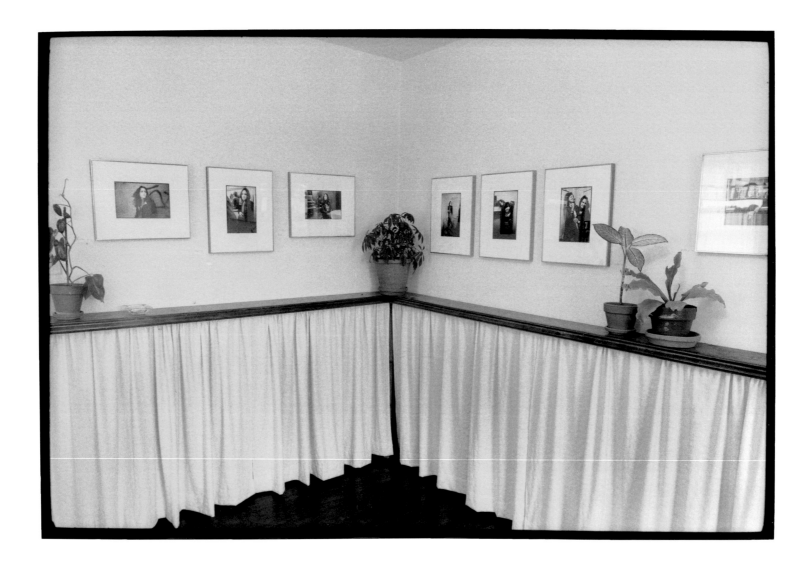

and Holly Woodlawn—the scions of the drag scene in New York and regulars at Max's Kansas City. They returned to San Francisco defeated. After a series of halfhearted acts back at home, in the fall of 1972 they recruited Divine to star in their last hurrah, *Vice Palace*, a comic song-and-dance show loosely adapted from Edgar Allan Poe's *Masque of the Red Death*. Three midnight performances, or "Nocturnal Dream Shows," were held at the Palace Theater on Halloween weekend, starring Divine (in the lead role of Signorina Divina), Goldie Glitters, Pristine Condition, John Rothermel, and Peter Arden.

Friedkin obtained permission to photograph backstage (see pls. 62–64) and during rehearsals. His pictures capture the camp extravaganza of the patrons and performers. This was the last appearance with the troupe for Peter Arden, who regularly accompanied John Rothermel on piano at concerts in other locations in the city. In *Vice Palace*, he played for Rothermel, recognized as the most talented of the Cockettes, blessed with a strong stage presence, a powerful singing voice, and a notable predilection for the music and fashions of the 1930s.[40] His drag costume consisted of original Art Deco gowns rescued from thrift stores and flea markets.[41] Working in low-light conditions, Friedkin photographed Arden

and Rothermel during rehearsal (see pl. 65), with Arden shown from behind and Rothermel cutting a slightly blurred figure, decked out in beads and a feather hat and clutching a mask. Another talented performer was Sylvester James—known simply as Sylvester—who was born and raised in Los Angeles and moved to San Francisco after he graduated from high school in 1969.[42] Friedkin photographed him backstage at the Palace (fig. 12), his face heavily made up and his bare midriff adorned with an animal skull. Sylvester sang as part of ensembles, but also regularly performed one-man shows that displayed his extensive repertoire of blues, soul, and gospel-inspired vocals.

THE GAY ESSAY: EXHIBITIONS AND CRITICAL RECEPTION

The Ohio Silver Gallery, a small, homespun venue in West Los Angeles, was the setting for the first public exhibition of *The Gay Essay*, from June 1 to July 8, 1973. Sixty-three photographs were included, neatly displayed in three small rooms, retaining a sense of intimacy appropriate to the work. The works were installed thematically, with the main gallery—recalling the austere elegance of Alfred

Fig. 13. Unknown photographer, *Installation View of "The Gay Essay" at the Ohio Silver Gallery, Los Angeles*, 1973
Gelatin silver print, 8 × 10 in. (20.3 × 25.4 cm)
Collection of the artist

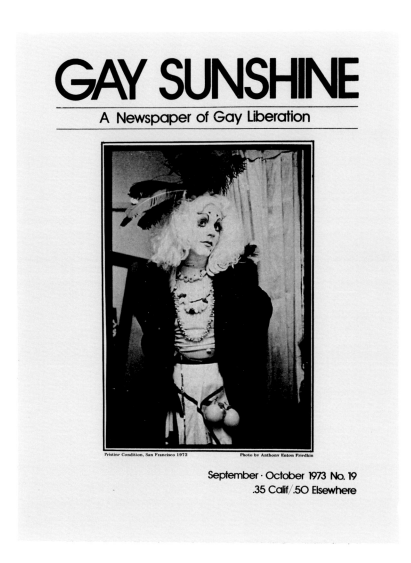

GAY SUNSHINE

A Newspaper of Gay Liberation

Pristine Condition, San Francisco 1972 Photo by Anthony Enton Friedkin

September · October 1973 No. 19
.35 Calif/.50 Elsewhere

Stieglitz's 291—accommodating six prints of Jim Aguilar, hung above a curtained shelf with the homey addition of four potted plants (fig. 13). The exhibition was reviewed by William Wilson for the *Los Angeles Times*, who criticized the series as being "incomplete" for its preoccupation with "those who have little to lose by being identified as members of the subculture. Gay people with positions in establishment society refused, out of fear, to have their images recorded."[43] Wilson's statement was not entirely true. Friedkin, preferring to spend time with his immediate peers, had not tried to get to know individuals entrenched in the corporate world or the mainstream.[44] His approach was spurred by youthful ideal-ism, a consideration that Wilson acidly addressed in his conclusion to the review: "Perhaps we learn nothing of homosexuals from Friedkin's essay. We do learn a good bit about a driven, young camera artist wracked with the problems of trying to be personally expressive, socially sympathetic and rationally detached, all at once."[45] Conversely, a writer for *Artweek* described the exhibition as "comparable in magnitude to Robert Frank's 'The Americans.' The show provides an unusual photographic experience for viewers of all kinds. For photographers it is partic-ularly significant for its strength of content and presentation."[46]

In the gay press, the response to Friedkin's project was enthusiastic and celebratory. A writer in *The Advocate* stated: "The gay culture as 'community' has finally arrived with its own 'Family of Man.' The photographic exhibition at the Ohio Silver gallery is evidence of the fact. . . . In the opinion of this spectator they are pictures of social significance. . . . Friedkin's work seems to capture a sense of awe about the many faceted gay scene."[47] The reviewer singles out the "androgynous" motif as being particularly well emphasized in the work, and highlights the post-operation photographs of Brandy (see pls. 53–56) and the gender-bending personae of the former Cockettes John Rothermel and Pristine Condition. Friedkin's portrait of Pristine Condition ran as the cover image of *Gay Sunshine* (fig. 14), which included a generous and eye-catching six-page spread on *The Gay Essay* accompanied by a brief statement about the photographer.[48] It is the most expansive representation of the project in print from the period, a time when it was almost impossible to find outlets for the exhibition and publication of such work in mainstream magazines and periodicals.[49]

THE GAY ESSAY: THE BOOK

Friedkin's goals for the project were ambitious from the start. Writing to John Szarkowski, curator of photography at the Museum of Modern Art, New York, in the summer of 1973, his words were assured and clear: "There are many reasons I chose to do this particular essay, in part because gay people are very misunderstood and mistreated by society and I wanted to document their lives. The experiences I had while photographing gay people were vastly different from one another. The discoveries I have made are in my photographs."[50] He goes on to outline the different subjects and sections of the work and concludes: "My concern for these photographs is tremendous. During the 18 months of shooting I had to borrow money from my friends. Magnum was generous and sent me money to finish the essay. My true desire is to have the pictures published in book form."[51]

Knowing that books allow for deeper reporting than magazine articles, Friedkin, from the moment he finished photographing for *The Gay Essay*, set out to create a book that would be tailored to the requirements of the project. The format allowed him complete authorial control over the presentation of the work. In the fall of 1973, Friedkin began working on a maquette that crystallized his commitment to the subject (fig. 15). In the introduction he penned, Friedkin stated: "I spent approximately eighteen months photographing gay people in Los Angeles and San Francisco and found the experience to be one of the most important in my life. . . . The experiences I had . . . were vastly different and at times beyond my own imagination. I found a tremendous honesty amongst them, a wonderful sense of the absurd and a fantastic passion. There is much to learn from the gay community."[52]

Despite his relatively wide exposure to photographic books and magazines, Friedkin did not try to emulate a specific title when making his maquette. He

Fig. 14. *Cover, "Gay Sunshine: A Newspaper of Gay Liberation,"* September–October 1973
Photograph by Anthony Friedkin
Collection of the artist

19

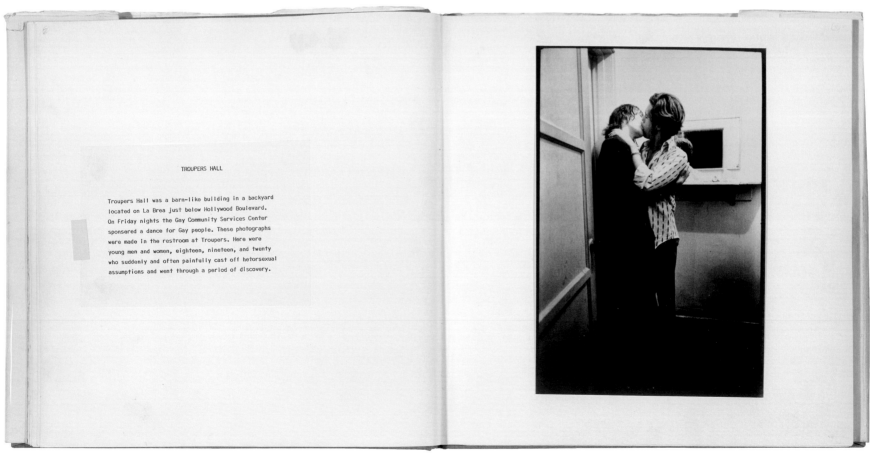

organized the photographs into seven sections or chapters: "Trouper's Hall," "The Christopher Street West Parade," "Hollywood," "Female Impersonators," "Portraits," "Theater, San Francisco," and "Jim Aguilar."[53] The order of the chapters and the sequencing of the pictures were developed independent of any didactic or aesthetic agenda, but Friedkin did go to great lengths to secure Morris Kight's involvement, inviting him to write an introduction. Kight was wary about doing so and was resistant to the idea of providing a definitive statement on Friedkin's photographs and what they said about the gay community and gay lifestyles. To keep the idea alive, Friedkin persuaded Kight to sit down for an extended conversation, which he audiotaped, transcribed, and then edited for the volume. The text (dated June 26, 1975), which was finally included in the maquette and signed by Kight, makes no comments on the photographs, but rather focuses on the plight of gays as "visitors in the village, not really belonging," and explains why it has been necessary for them to remain in their distinct community. The unedited transcripts provide interesting insight regarding the scope of the essay and the way that the gay community changed in the few short years between 1969, when Friedkin started the project, and 1973, when he began planning the book.

Kight was impressed by the specificity captured in Friedkin's pictures. Referring to the Trouper's Hall photographs (see pls. 1–7), Kight remarked: "Here was a moment. A year, a year and a half at most in gay history that will probably never happen again in quite the same way. Trouper's Hall was a moment of discovery . . . here were young men and women, eighteen, nineteen, twenty, who suddenly and often painfully cast off the heterosexual assumptions and went through a period of discovery and you came with your camera and trapped that."[54] The final edited version of Kight's introduction filled two double-spaced typed pages in the book maquette, and Friedkin also quoted Kight verbatim in some of the texts used to introduce various sections of the essay (fig. 16).

Kight's exchange with Friedkin suggested some of the pressures he experienced as a leader in the gay community and the responsibility that weighed upon him as a spokesperson for the liberation movement. Their discussion is frank and, in parts, confessional. Friedkin revealed: "I was going through an enormous amount of self discovery about my own sexual feelings when I was making the work. . . . I was concerned with registering an expression."[55] Kight responded by expounding on the mutability of human behavior and the need for gay people, in particular, to accept that their definitions of themselves are not fixed and their process of self-discovery is ongoing. In so doing, he pointed to one of the values of Friedkin's project: "We don't know who we are and that is all the more reason why your essay is priceless, because it tells who we are."[56]

What is distinctive, and essential to grasping the originality of *The Gay Essay*, is the degree to which, at such a young age, Friedkin showed sympathetic curiosity and genuine compassion for his subjects. He comprehended the authenticity of individual perceptions and full-bloodedly approached photography as a means to unlock his lived experience, and he used the medium to identify his place in the world. He also was not afraid to embellish found reality with a frisson of fantasy, to suggest the myriad ways that dreams of freedom and love are alive and working in most of us. At the time, Friedkin stated: "I think my work will function on many levels. If there are final truths about how I feel about my life, the photographs will hold traces of it."[57] Of course, photographs can and do change their meaning over time. But perhaps the most important and striking "trace" that permeates this work is the photographer's unflinching commitment to show intimacy and affection, and the expression of love between people of the same sex. What we are left with is a beautiful, sensitive record fit for the ages.

1 *Camera* 8 (August 1970): 40–44, 48. The magazine reproduces four photographs Friedkin made during his European travels and provides a brief statement about the photographer, from which this information is drawn. For an overview of Friedkin's photographic career, see Julian Cox, *Timekeeper: Anthony Friedkin* (Los Angeles: Enton Publishing Co., 2003).

2 For a succinct description of the Stonewall Uprising, see Linda Hirshman, *Victory: The Triumphant Gay Revolution* (New York: HarperCollins, 2012), 95–128. The landmark history of Stonewall was written by the gay historian Martin B. Duberman, *Stonewall* (New York: Plume, 1993).

3 W. Dorr Legg was a leader in the homophile movement of the 1950s and a founder of ONE, Inc., in Los Angeles, which produced the magazine *ONE*, the first widely distributed gay publication in the United States. See Hirshman, *Victory*, 43–44.

4 "Homosexuality—25 Questions & Answers" (Los Angeles: Institute for the Study of Human Resources, 1967), in Group Ephemera folder for the Institute for the Study of Human Resources, Archives of the Gay, Lesbian, Bisexual, Transgender Historical Society, San Francisco.

5 *Life* 56, no. 26 (June 26, 1964). The story consists of two articles: Paul Welch, "The 'Gay' World Takes to the City Streets," 66–74, and Ernest Havemann, "Scientists Search for the Answers to a Touchy and Puzzling Question: Why?" 76–80.

6 Welch, "The 'Gay' World," 68, 74.

7 Ibid., 66, 71.

8 Among David Friedkin's writer/director credits are *The Pawnbroker* (1964) and *I Spy* (1965).

9 David Friedkin purchased a copy of Henri Cartier-Bresson's *The Decisive Moment* (New York: Simon & Schuster, 1952), which Anthony Friedkin has vivid memories of reading as a young adult. Email from the artist to the author, November 13, 2013.

10 Email from the artist to the author, November 13, 2013.

11 See Julian Cox, *Spirit into Matter: The Photographs of Edmund Teske* (Los Angeles: J. Paul Getty Museum, 2004).

12 *Camera* 8 (August 1970): 49.

13 Cornell Capa, quoted in Brett Abbott, *Engaged Observers: Documentary Photography since the Sixties* (Los Angeles: J. Paul Getty Museum, 2010), 15.

14 See Chris Boot, ed., *Magnum Stories* (London: Phaidon Press, 2004).

15 See *Camera* 8 (August 1970): 40–44, 49.

16 Ibid., 49. The biography reveals that "Friedkin encountered many problems posed by East Berlin restrictions. Among other things, he was arrested, interrogated and threatened, and when he left he was forced to conceal his film in his shoes when he walked across the border."

17 Charles Harbutt, quoted in Richard Busch, "Anthony Enton Friedkin: Probing the Environment," *Popular Photography* 71, no. 6 (December 1972): 106 (article 106–109).

18 Anthony Friedkin, correspondence with the author, November 13, 2013.

19 Henri Cartier-Bresson, typeset statement in Fondation Henri Cartier-Bresson archives, Paris, n.d., quoted in Abbott, *Engaged Observers*, 13.

20 John Szarkowski, quoted in Abbott, *Engaged Observers*, 50. The statement comes from the wall text provided by Szarkowski for the *New Documents* exhibition at MoMA in 1967.

21 *The Family of Man* was the Museum of Modern Art's groundbreaking exhibition of 1955, organized by the curator Edward Steichen. It was seen by more than nine million people both in the United States and when it traveled abroad. See Eric J. Sandeen, *Picturing an Exhibition: The Family of Man and 1950s America* (Albuquerque: University of New Mexico Press, 1995), 39–75; and Glenn G. Willumson, *W. Eugene Smith and the Photographic Essay* (Cambridge and New York: Cambridge University Press, 1992).

22 Danny Lyon, *The Bikeriders* (New York: Macmillan, 1968). The first edition is long out of print, but the book was republished in 2003 by powerHouse, New York, and has recently been republished again by the Aperture Foundation (2014).

23 For a succinct and informative discussion of the photo book during this period, see Abbott, *Engaged Observers*, 18–26.

24 It occupied his time intensively from the fall of 1969 through the spring of 1973. Study of Friedkin's negatives reveals that he shot more than 170 rolls of 35mm black-and-white film between 1969 and 1973 to produce *The Gay Essay*. Friedkin's numbering system for the negatives is not chronological, and there are occasional inconsistencies and breaks in the sequence. The negatives are numbered and identified as follows: 1–19, Jim Aguilar; 20–35, Trouper's Hall; 36–60, Prostitutes; 61–90, Female Impersonators; 91–106, Cockettes/Palace Theater; 107–112, Hustlers and Hollywood; 113–150, Portraits; 151–159, Picnic; 160–164, Gay March; 165–168, Miscellaneous; and 169–175, Brandy, Transsexual. The Fine Arts Museums of San Francisco has the largest collection of vintage prints from *The Gay Essay* (ninety-four prints). Significant holdings from the series also exist at the International Center of Photography, New York (sixty-two prints), the J. Paul Getty Museum, Los Angeles (fifteen prints), and the Los Angeles County Museum of Art (twelve prints).

25 Don Kilhefner's article ran with the headline "Gay and need draft counseling? V.D. information? Alcohol problem? Legal advice? Just want to know where the groovy bars are? Being evicted? Drug problems? Police getting you down? Anything we can do to help? Sure, just give us a call. GLF Survival Committee, 665-1881." *Los Angeles Free Press*, August 14, 1970, 62. The article begins with a quote: "To love we must survive / To survive we must fight / To fight we must love. . . ." Kilhefner's article was part of a special Gay Liberation Supplement, 50–63, which also included texts by Morris Kight, Lee Heflin, and Carl Wittman.

26 Morris Kight, unedited transcript of a conversation with Anthony Friedkin, page 3 of a 29-page unpublished manuscript, ca. 1973. (Collection of the artist.)

27 See Kay Tobin and Randy Wicker, *The Gay Crusaders* (New York: Paperback Library, 1972), 19–20. See also Hirshman, *Victory*, 140–145.

28 Friedkin exposed more than fifteen rolls of 35mm film at Perry's church; they are filed within his negatives "113–150 Portraits." (Collection of the artist.)

29 For a description of the fire and Perry's response to it, see *The Advocate* 106 (February 28, 1973): 3, 19. For Perry's activism and his work with the MCC, see also Hirshman, *Victory*, 144–145.

30 *The Advocate* 106 (February 28, 1973): 5. A full-page advertisement ran here with Friedkin's photograph and a text by Perry, who stated, "To those people who would rejoice because of our loss: WE SERVE YOU NOTICE—that we, in the Gay community, will never permit the hands of the clock to be turned back on us—ever again! We WILL rebuild and go forward!" The same advertisement also ran two weeks earlier in *Variety* (February 12, 1973): 5.

31 See Hirshman, *Victory*, 144.

32 Morris Kight describes the genesis of the Christopher Street West Parade and its community impact in "The Great Parade: Christopher Street West," *Los Angeles Free Press* (August 14, 1970): 51, 62.

33 This description appears in Friedkin's book maquette for *The Gay Essay*, opposite the portrait of Jim Aguilar that is reproduced as pl. 71 in this book. (Collection of the artist.)

34 See Nan Goldin, David Armstrong, Mark Morrisroe, Jack Pierson, and Philip-Lorca diCorcia, *Emotions & Relations* (Los Angeles: Taschen, 1998); and Walter Keller and Hans Werner Holzwarth, eds., *A Double Life: Nan Goldin and David Armstrong* (New York, Zurich, Berlin: Scalo Publishers, 1994).

35 Morris Kight found the photographs of Dan the Hustler problematic. While he understood the social dynamics of male prostitution, he was saddened by it and believed that the transaction of sex for money was unpalatable: "Deep in my heart I think that love should not be sold. I think it should be given away to people who are capable of receiving it and are ready to receive it." See Kight, unedited transcript of a conversation with Anthony Friedkin, 26.

36 Welch, "The 'Gay' World," 68, 71.

37 Anthony Friedkin, correspondence with the author, December 19, 2013.

38 Numerous articles were published about the Cockettes during the period. See, for example, Maitland Zane, "Les Cockettes de San Francisco," *Rolling Stone* (October 14, 1971): 33–35; Barbara Falconer (text), "The Cockettes of San Francisco," *Earth* 2, no. 8 (October 1971): 40–59; and Joan Wiener, "Cockettes," *Rags* (August 1970): 40–43.

39 John Waters speaks about Divine (whose given name was Harris Glenn Milstead) and the Cockettes in the documentary film *The Cockettes* (2002), directed by David Weissman and Bill Webber.

40 See the Peter Mintun Cockettes Collection (GLC 78), Gay and Lesbian Center, San Francisco Public Library. Peter Arden was Peter Mintun's stage name. The collection includes photographs, sheet music, song lists, posters, playbills, and other ephemera relating to the Cockettes. See folder 31 for a press release describing the production of *Vice Palace*.

41 See "John Rothermel Sings Cole Porter Love Songs in a Dress," *San Francisco Sunday Examiner and Chronicle*, Sunday, December 30, 1973, 15.

42 See the Biographical Ephemera files, Archives of the Gay, Lesbian, Bisexual, Transgender Historical Society, San Francisco. The funeral program for Sylvester James lists his life dates as 1947–1988.

43 William Wilson, review, "Gay World in Photos by Friedkin," *Los Angeles Times*, July 12, 1973, part V, 8.

44 In 1980, Friedkin readily acknowledged that his images were not representative of the entire gay community and remarked that when making *The Gay Essay* he was drawn "to people whom he found most interesting—personally and photographically." See *Los Angeles Herald Examiner*, January 20, 1980, Style section, G8.

45 Wilson, "Gay World in Photos by Friedkin," 8. Ironically, Christopher Knight reviewed a 2009 exhibition of *The Gay Essay* at the Darkroom Gallery, Los Angeles, and stated that the photographs "embrace taking part in the diversity of gay experience that publicly emerged in Stonewall's wake." Christopher Knight, "When the Closet Door Cracked Open," *Los Angeles Times*, July 10, 2009, Calendar section.

46 Robert J. Mautner, review, "The Gay Community," *Artweek* (June 23, 1973): 12.

47 Joseph Lambert, review, "Friedkin Focuses on Gay World in Photo Exhibit," *The Advocate* 115 (July 4, 1973): 25.

48 *Gay Sunshine: A Newspaper of Gay Liberation* 19 (September–October 1973): 6–11. Sixteen photographs are reproduced, all of which appear in the present catalogue.

49 *The Gay Essay* has been exhibited in various guises since its first public presentation at the Ohio Silver gallery, Los Angeles, June 1–July 8, 1973. The most notable exhibitions include those at Cameravision, Los Angeles, January 18–February 17, 1980; Stephen Cohen Gallery, Los Angeles, June 7–July 19, 1994; and Darkroom Gallery, Los Angeles, June 20–August 2, 2009. The exhibition that accompanies this publication is the most complete presentation to date of *The Gay Essay*.

50 Letter from Anthony Friedkin to John Szarkowski, July 17, 1973. (Collection of the artist.)

51 Ibid.

52 Friedkin's introductory text, as quoted here, is dated December 1973. Only one copy of the book survives. (Collection of the artist.) The same language appears in a statement that Friedkin wrote to accompany an article titled "The Gay World: A Photo Essay by Anthony E. Friedkin, Looking beyond the Labels to a Fresh Picture of the Homosexual Community," which was illustrated with a selection of photographs from *The Gay Essay*. See *Human Behavior: The News Magazine of the Social Sciences* 2, no. 12 (December 1973): 36–43.

53 These sections have been preserved, and in the same order, in this publication. The sequencing of the photographs within each section has changed as a consequence of a dialogue among the photographer, the author, and the book designer. The original book maquette included fifty-one plates; this book has seventy-one.

54 Kight, unedited transcript of a conversation with Anthony Friedkin, ca. 1973, 2, 3.

55 Ibid., 12.

56 Ibid., 23.

57 Anthony Friedkin, quoted in Lambert, "Friedkin Focuses on Gay World," 25.

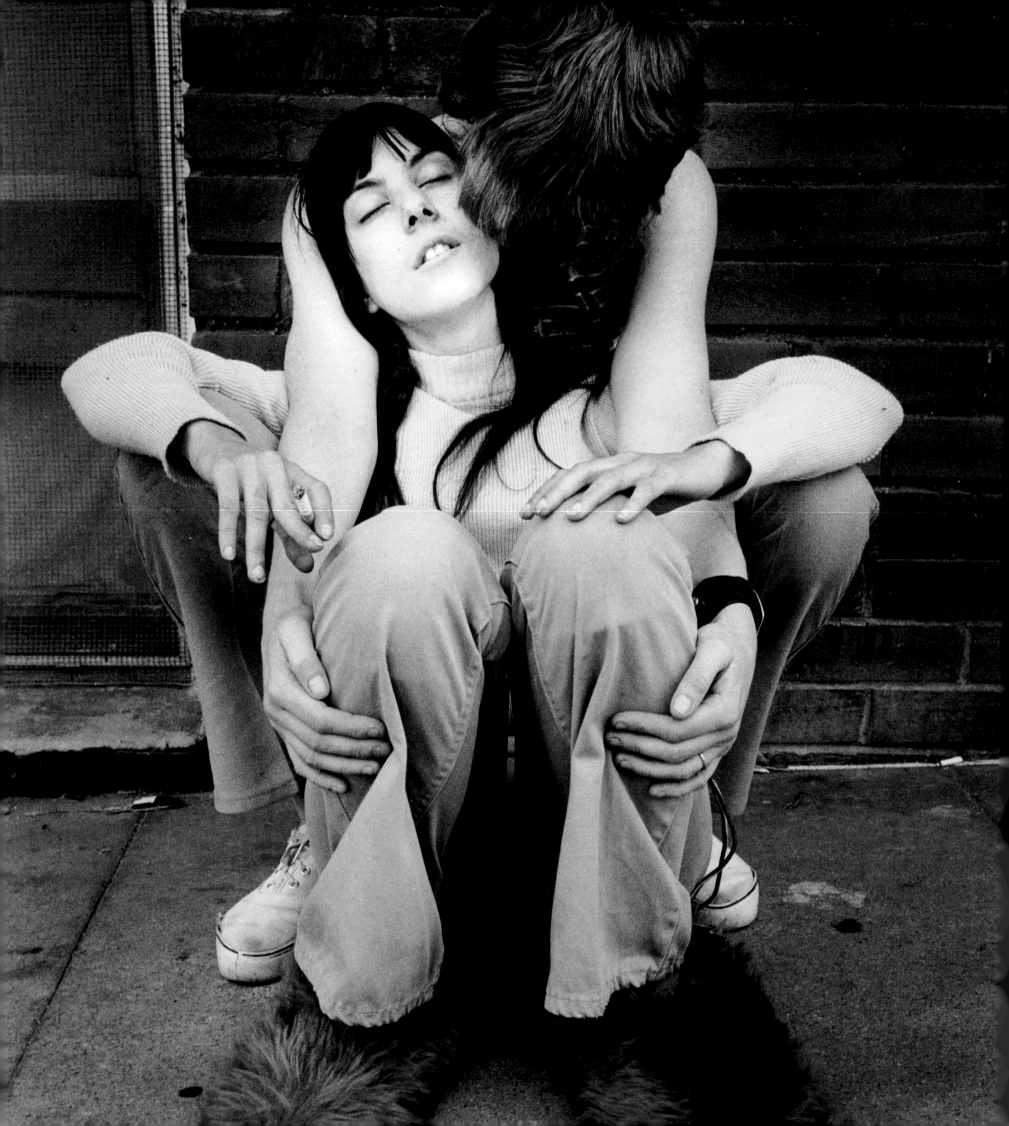

AND *I'M* CARMEN MIRANDA
WHAT LIBERATION LOOKS LIKE

NAYLAND BLAKE

IT IS SAID that we cannot truly retain the memory of pain, but surely joy is even more difficult to recall. Pain, struggle, and striving seem, because of their gravity, more appropriate subjects than pleasure for memory and reconsideration. When we ask photography, especially documentary photography, to be our memory and conscience, to capture and record truth, it is almost always images of struggle and pain that we are thinking of. Recent photographic theory has revolved around two concepts: the slipperiness of photography's claim to veracity and the moral implications of recording and witnessing what Susan Sontag called "the pain of others." These discussions make little room for emotions other than suffering, and when they do, it is more often than not to point out the failure of projects that attempt to turn photographic subjects into symbols of universal humanity. Pleasure, joy, and ecstasy all seem less noble, undeserving of serious discussion. Perhaps because these states seem more situated in our bodies, we distrust them.

It is this thinking that has dogged the political struggle of queer people since its inception. Because it is so difficult to argue for sexual pleasure, to argue for the truth of our bodies, the Lesbian and Gay communities have had to make a different argument, one based on a notion of equal rights, a rational argument that takes as its template the American civil rights movement of the fifties and sixties. This story of struggle, one whose roots stretch all the way back to the Enlightenment, has been portrayed with certain kinds of images: sober depictions of adverse conditions, humanizing pictures of members of minority groups, portraits of community leaders and organizers, and pictures caught on the fly at street protests.

There is a different story that laces its way through the photographs of *The Gay Essay*, and it is a story of joy, of facing an indifferent and hostile world with something other than a grimace. Friedkin's pictures, made during the crucial years just after Stonewall, trace the emergence of a public Gayness, a new face on the streets of America, one with a history as rich as that of the years preceding the rumblings of Gay Liberation.

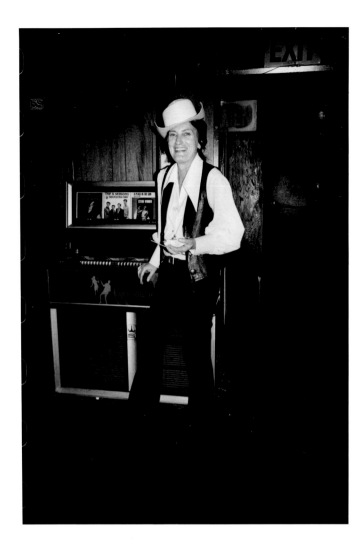

public events. It is Friedkin's other pictures, the pictures of the people who will never be stars, except to one another, people who win their freedom and love day by day—it is these pictures that caught my compassion and made me look again.

And as I spent more time with Friedkin's work, I began to see a transition: first in the spaces that Friedkin seemed to be shooting, and then in the attitudes of the people who inhabited those spaces. The volcanic events of Stonewall and the Summer of Love lay between Eppridge's pictures and Friedkin's. Groups had begun speaking about Lesbian and Gay Liberation. As I started looking for the stories that were obscured by the standard one, I began to ask myself this question: What does liberation look like?

First, its precursor: A portly man stands silhouetted against the LA sun, his shadow slanting onto a wall with a rendering of Michelangelo's *David* (with an appliquéd fig leaf) and a series of signs (pl. 17):

A Warehouse of Wild and Woolly Adult Entertainment!
All Male Film Festival
2 Hours in Gay Color!
For Men Only!

He is almost past the entrance, hands shoved into pockets, face obscured by shadow. He could be entering or leaving, but in either case, his diffidence is palpable.

And next, an image presumably from inside the Wild and Woolly Warehouse: two men sit, backs to the camera, in seats that seem to have no space between them, and at the center of the picture is a grainy, chopped-down rectangle of hard-core action (pl. 18).

In both pictures, Friedkin's clear eye and sturdy compositions make specific editorial points; the men are squeezed into the frame, faceless, either because they are turned away from us or because of the shadows. The focus is the porn theater itself as a location that is both cheap and cramped. The men are merely exemplars, the older one looming slightly over the younger one. And even the street outside feels like an interior; there is no sky, no horizon. In these images, as in many of his pictures, Friedkin brings us into a world that is a confined safe haven in the midst of a hostile environment.

People's attitudes in other pictures are marked by wariness, defiance, or determination: the guarded calculation of a hustler displaying the goods (pl. 16); a gallant butch cowgirl next to the men's room at a bar (fig. 17); a line of female impersonators at the "Queen's Ball," fully confident in their illusion and ready for the stage (pl. 30); or Reverend Troy Perry, resolute in the ashes of the church he founded (pl. 40).

Each of these people inhabits a role that seems to be offered by the camera itself, presenting an identity that, however controversial, is still recognizable: entertainer, activist, whore. They are embodiments of types. At the point that Friedkin undertook his project, two forces were at work in gay life. The first was

My first encounter with these pictures was utterly by accident: as I began work on another project, one involving the early years of the leather scene in San Francisco, International Center of Photography curator Brian Wallis suggested that I might want to look at Anthony Friedkin's pictures. They appeared, at first blush, casual, exploratory, and not particularly revealing. *The Gay Essay* contains examples of the types of pictures I mention above, pictures firmly within the civil rights documentary tradition, an approach that first saw print in *Life* magazine's groundbreaking article "Homosexuality in America," published on June 26, 1964, with pictures by Bill Eppridge (fig. 1). Friedkin's pictures seemed to cover ground similar to Eppridge's: the cities of Los Angeles and San Francisco, and their fledgling bars and community centers, streets, and adult theaters—peeks into worlds heretofore hidden from straight eyes.

I wasn't especially interested in the community leaders and the civil rights story that is told in these pictures and that in large part was already defined by the *Life* article: cops harassing, leaders organizing, spokespeople being anointed, and parades and the bigots who attend parades to yell. Certainly Friedkin captures in these photos the stuff that passes from news into history. But these pictures do not really give us a sense of what is at stake for the people caught up in these

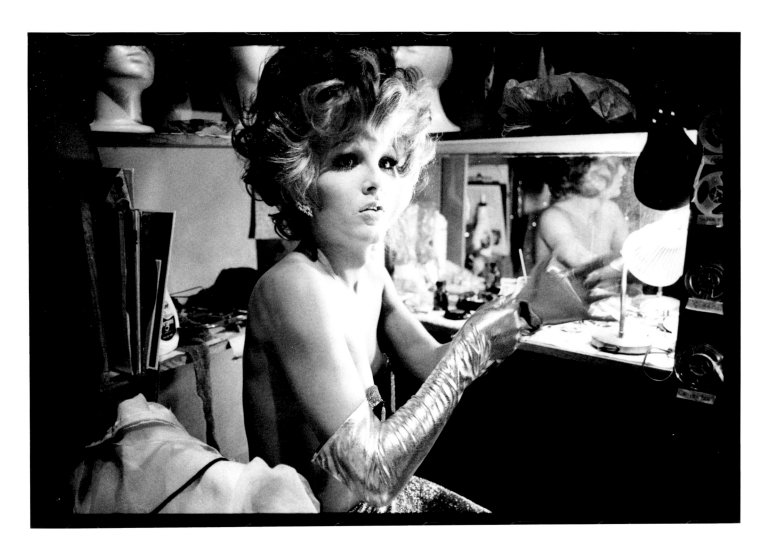

the recognition of these types; the second was the development of a new, self-aware gay style.

Photography itself exists in the space of contradiction: it captures the unique moment that is occurring in front of the lens at the instant the shutter opens. In that sense, each photographic image is sui generis. Yet photography also tells us stories by showing how that unique moment is also a typical one, how it resembles images we have seen before it. When we are the subjects of photographs, we collude with this process; we have become so habituated to the camera that we arrange ourselves in ways that are familiar to us because such ways are derived from all the other pictures we have seen. We are addressing an audience. And at the time that Friedkin was shooting this project, that audience was rarely a sympathetic one.

And that is when my enthusiasm for these pictures began to grow: I started to look at those pictures where Friedkin photographed people whose audience *is* sympathetic, where couples or groups of people are enacting their queerness for one another, and not for the world at large.

A group of these pictures (pls. 59–65) was shot at a performance by San Francisco's Cockettes, the extended commune/performance troupe that melded flower power and camp into a style that was a rebuke to any hope that gay people would fit into the wider world. Friedkin's pictures catch the thrill of people who hope to transform their world through the smallest gestures. Here are some of my favorites:

A fabulous couple standing in line outside the Palace Theater, all tossed-on finery and buzzing anticipation: one with bangles and a proper clutch, frizzy hair and a glittered goatee. Another is nonchalant in an old band jacket, fishnets, and a garter (pl. 60). If this is drag, what is the role that they are putting on? Who is being impersonated? No one. Instead genders are being mashed up, played with, made elastic, and revealed to be a matter of personal style. This couple is dressed for themselves and each other.

The Cockettes' shows were notoriously ramshackle, closer to "Happenings" than to polished performances, and the charm of that slapdash approach is visible in Friedkin's picture of Pristine Condition, who sports necklaces of candy corn, Bette Davis eyebrows, and an improbable bunch of feathers bursting from her head (pl. 59). The picture captures a sweetness that seems very different from the measured self-presentation of his image of Michelle, a female impersonator at the "C'est La Vie" Club in North Hollywood (fig. 18 and pls. 32–34). Pristine is

Fig. 18. Anthony Friedkin, *Michelle Backstage, "C'est La Vie" Club, North Hollywood*, 1972
Gelatin silver print, 11 × 14 in. (27.9 × 35.6 cm)
Fine Arts Museums of San Francisco, anonymous gift, 2011.58.10

not perfecting an illusion; she is part of a scene where the roles of audience and actor are almost interchangeable. Michelle is part of a show, and she has a craft and a very specific type of femininity that she projects. She uses her position in front of Friedkin's camera to connect to a long line of Hollywood glamour queens. More important, one image is drawing on the known or the typical, and one is fusing together fragments to create something new.

Another couple: In contrast to the stalwart butch cowgirl in the bar, there is a picture of pure adoration: one woman, an ankh medallion around her neck, indulgently looks on while her charming trick? partner? girlfriend? swaggers against the wall, cigarette dangling (pl. 24). This is what freedom looks like: sweetness, silliness, and defiance. Yes, the woman in the cropped jean jacket is putting on a show—in part for the camera, but more importantly for her pal, and the acceptance that she has won from both parties makes her irresistible.

In another picture, both women playfully bump crotches against a wall outdoors, and the first woman's look of love is undiminished, even amplified, perhaps, by the bravery of flirting and taking your pleasure however you want it, right there in the street (pl. 23). The difference between the way these women light up the street and the shadowed, guarded faces of the men in and around the porn theater is the mark of history being made; it is exactly what liberation looks like.

As the seventies wore on, the various parts of the gay and lesbian community fragmented and, as some would put it, matured. For the most part, this meant that as the various communities drew farther apart, they developed more coherent internal identities. "Gay and Lesbian Rights" replaced "Gay Liberation," and earnestness replaced frivolity. There was a possibility of achieving a place in society, and that possibility brought with it the temptation to conform to society's expectations.

The flimsy nature of that possibility was revealed when the AIDS epidemic showed how far society was from any real acceptance of Queer people. It also made clear to a new generation the power that comes from controlling and articulating your own image. Streets around the world once again became a forum for people to make visible their own truths. By the late 1980s, Gay pride parades had transformed into crosses between funeral marches and political rallies. The poster and the placard, the T-shirt and the sticker, became the locales of people's declarations and self-advertisements.

I had the opportunity to think about Friedkin's pictures once again this past summer as I worked on *Knee Deep in the Flooded Victory*, a project for the International Center of Photography. In it, I tried to draw parallels among several bodies of work that were part of the ICP's collection: Friedkin's work of the early seventies, Queer protest posters of the early nineties, and my own performances and 'zines exploring the state of Queer identities today. I was thinking about the street as a stage, the place where we still have the ability to break down and reconfigure identities, the place where the pageant might still have power. I was

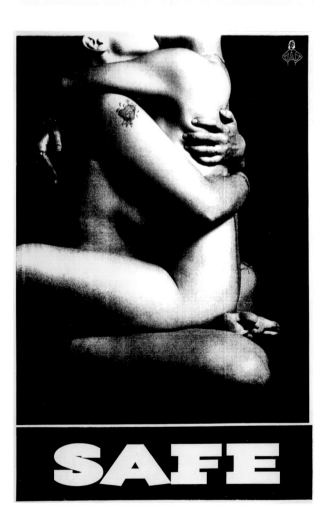

I AM A stone butch androgyne femme tomboy girlfriend sapphic deviant

AND PROUD

SAFE

Fig. 19. fierce pussy, New York, *I Am a Stone Butch*, 1991–1995
Xerograph, 11 × 8 ½ in. (27.9 × 21.6 cm)
International Center of Photography, Purchase, with funds provided
by the ICP Acquisitions Committee, 2000

Fig. 20. Girls with Arms Akimbo, San Francisco, *SAFE*, 1990–1991
Photocopy on paper, 17 × 11 in. (43.2 × 27.9 cm)
International Center of Photography, Purchase, with funds provided
by the ICP Acquisitions Committee, 2000

also thinking about the ways that museums can activate their collections so that they can work as engines for social change.

Among the many items I included in this installation were two posters by lesbian collectives: one by New York's fierce pussy (fig. 19) and one by San Francisco's Girls with Arms Akimbo (fig. 20). Both exhibit the kind of self-defining Queer voice that I spoke about earlier, the voice that I both hear and see in some of Friedkin's pictures.

The Girls with Arms Akimbo poster juxtaposes a photograph of two naked women wrapped in a seated embrace with the single word "SAFE" at the bottom of the frame. First, this is a reference to safe sex, but beyond that it is an assertion of the safety and joy found in the arms of a lover, and beyond that it is a declaration that the streets where the poster was displayed are places where same-sex couplings, and the representation of Queer bodies, are safe. It shows the way that we create our own safety through acknowledging our truth.

On the fierce pussy poster is another declaration: "I AM A stone butch androgyne femme tomboy girlfriend sapphic deviant AND PROUD." Here again is a place where the stereotype is shattered and recombined: my pride comes from being all these things, from containing multitudes, from wearing identities in succession, and from discarding them at will. The relish behind this series of terms is the same one that I detect in the eyes of the lesbian couple in Friedkin's pictures.

And, finally, I chose a protest sign from an ACT UP action: a card that bears Ed Koch's famous front-page declaration "I'm Heterosexual," followed with an anonymous protester's riposte: "And *I'm* Carmen Miranda" (fig. 21). This is a long, long way from the shadowy men ducking off the street into the wild and woolly world of all-male adult entertainment. These four words aimed at a politician widely believed to be closeted are unshamable, puckish—the kind of frivolous, wacky response that so quickly fades from memory. It is the place where anger must become wit or consume itself in frustration. It is a moment in history when an individual confronts society and refuses to accept its terms. It is the only kind of history that matters to me.

These explosions of joy and these flowerings are fleeting, and yet they are exactly what was historically important about Gay Liberation. They are declarations of something new on the streets and in the lives of Americans. The chance to be unconfined, to make ourselves look and to love how we choose, to find pleasure on our own terms—all this potential sings out to us through Friedkin's images, and it is all the sweeter for how quickly it can be forgotten. We may define ourselves by our struggles, but it is in the compilation of our joys that we fly free.

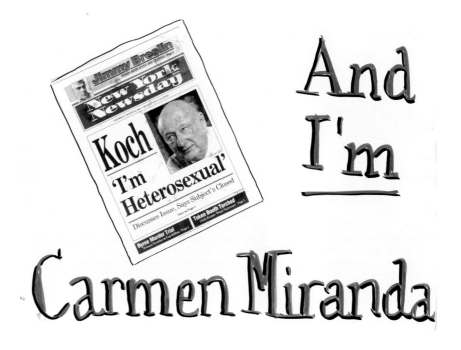

Fig. 21. ACT UP New York, *Koch: "I'm Heterosexual" and I'm Carmen Miranda*, 1989
Poster, color photocopy and marker on foamcore, 24 ¾ × 31 ½ in. (62.9 × 80 cm)
International Center of Photography, Purchase, with funds provided by the ICP Acquisitions
Committee, 2000

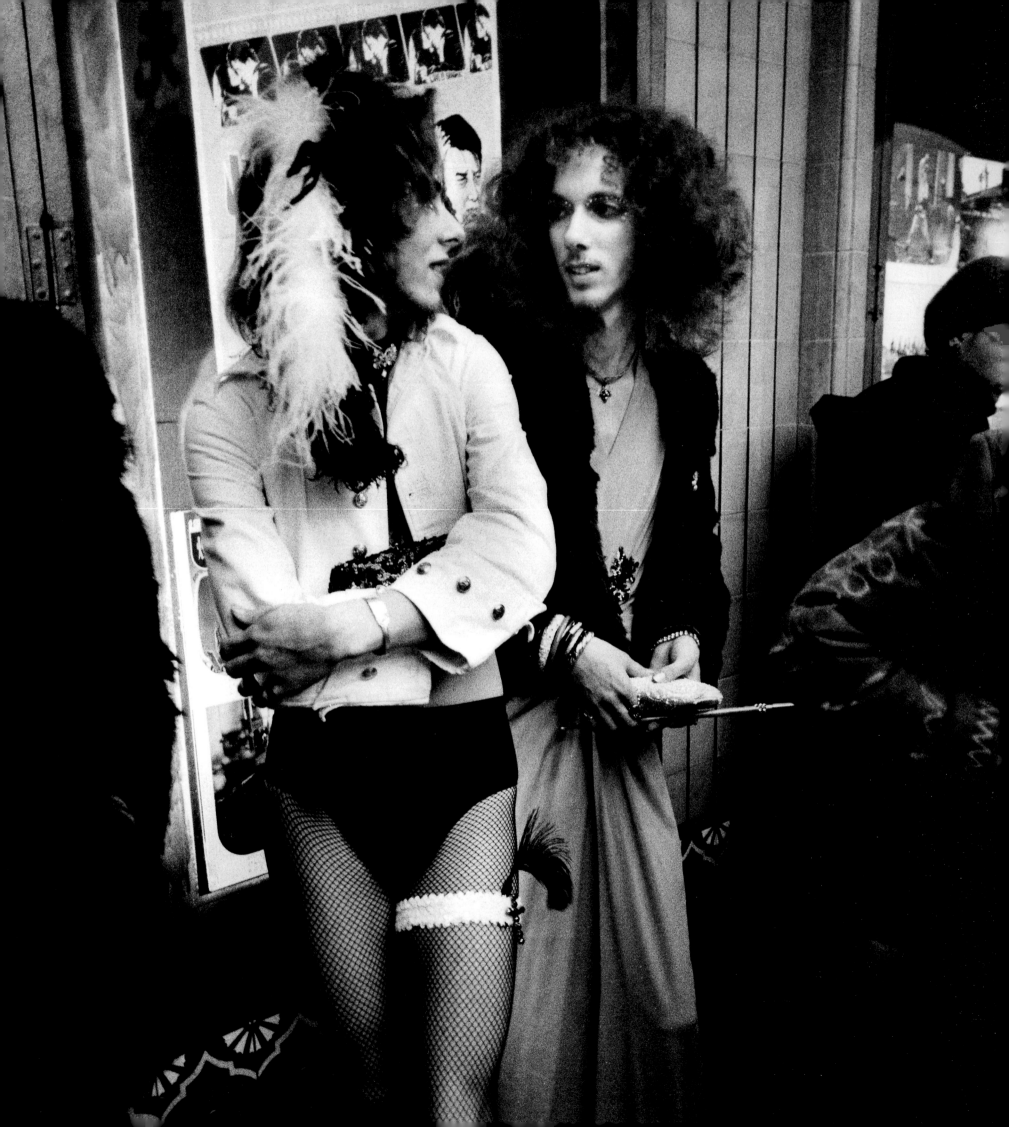

GAY AS A

EILEEN MYLES

It strikes me as pathetic and even filled
With glee. Her cat's-eye grin and the sor-
Rowful turn covered in jewels; the three
Of you in your pocketed shirts
She leans her small tits and great
Chest the stripes lining with the slats
Every detail in a dressing room the overwrought
Old-fashioned they burned 17 churches
In the '70s gay means this heartbreak-
Ing glee voluptuous her arms thrown
Around these fingers on her naked
Back the face mopped by her lovers
Hair it's too much. Her makeup while all the loving
Spoonful haircuts reflected your sweet face
And your bony hand and angles of graffiti
Curbs and stairs the whole cold world
Coming up behind you. Your eyebrows
And your trow. I finally know how
To make a fire and I can't tell you
Now my hustler in a cheap room
Full and sweet. Is that a mask. The light likes
You. My tide, my picnic. You are the saddest

Face of all what is it cat-like bouf-
Fant biting your lip not president. In Italy
We are doing our job. Feet dangling
I want my boyhood now. Your song leaning
Out. At least I'm fucking warm. Your makeup
And sleepy wee baby face against his
Twinkling elf-you. At least you, well you
Didn't have to move the furniture first
And let him change the room. It's the language
Breaks us cause I whispered to your fea-
Thers and I loved the way you turned
It's our decade baby. Arcade elbows
Leg muff, who's cuddly now
I wish that I could plaid for in that that
Is so long over. Not crotch not inno-
Cent angle not pouf hairline. Your eyes are a crime
Your paw echoing like a puppet's. But wait
That curl, that tiny strand. Everywhere
Baby there's too many pock-
Ets. Gay couple kissing
I'm planting it on your mouth
Cause we're already
Done. It's so young. The extra shelves and the mirrors
It was in another world. Mister your col-
Lar and the ladies
Have one too. Don't hold back
The dark I'll hold
Back your hair. I'll say good-
Bye to a statue. I'm tugging
Along. I just gotta go
Soignée, dripping doors
No one even sees us now
Again I'm holding above
The sumptuous mound
Of your ass. Don't go; put it right
In my face again. Triumphant
And blonde. Signs, cock stoppers
When I see your face and he's about the business
And the whole world is carrying on and I
Know he is your friend. Look me straight
In the eyes with your pearls and your
Voracious moods and your echoing
Crotch, I was only your lover
I was never your friend and you're
Watching me go. It was I?

It was I in her dark crotch. It was I in her
Hand, impish and good legs, it was I
The two tangled balls and her black
Feather gaze. You got something
You want to tell me. You were yawning
On the float. I could just eat
You in the grass. The balloon and I
Remember your intensity
There is nothing in the past
She with her baby fat and stub
Girls Girls but we're just putting on a
Show gravy train wants to go home
Girls I'll rub it in so good, girls
So light and so soft, so conniving
Cock hangs, light swarming
Apocryphal hair, you king
You lippy gaze, you are the Zanzibar
You are the dolls repeating forever
Make me stop dare you threaten
With your skinny legs and your
Cock. How about I lean like
This and I get skinnier
And younger now
And what did you just say?
Like this, now. Like this.
O I think you'll like it
A lot. And I can smell
You now. And I like the
Way your teeth gleam.

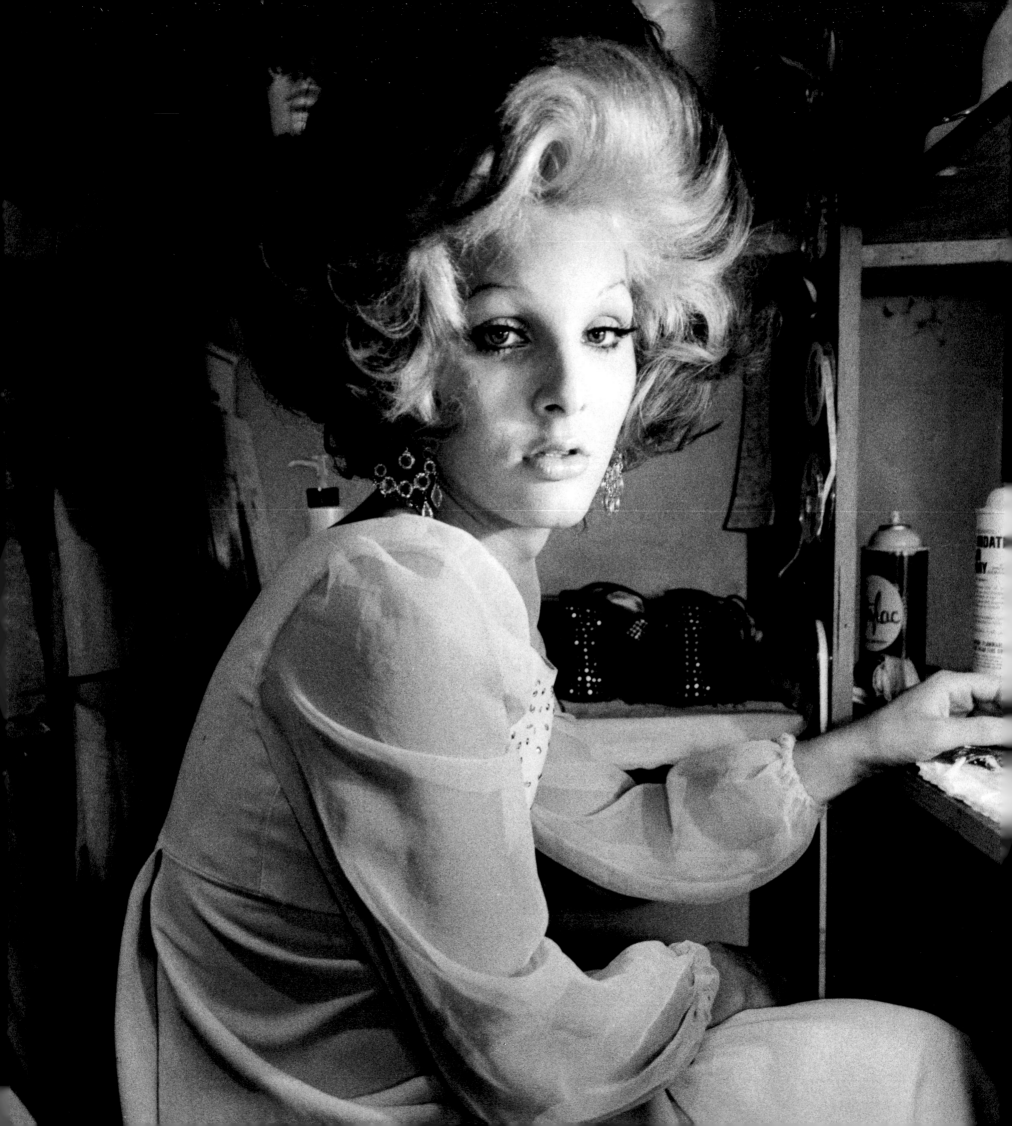

PLATES

TROUPER'S HALL

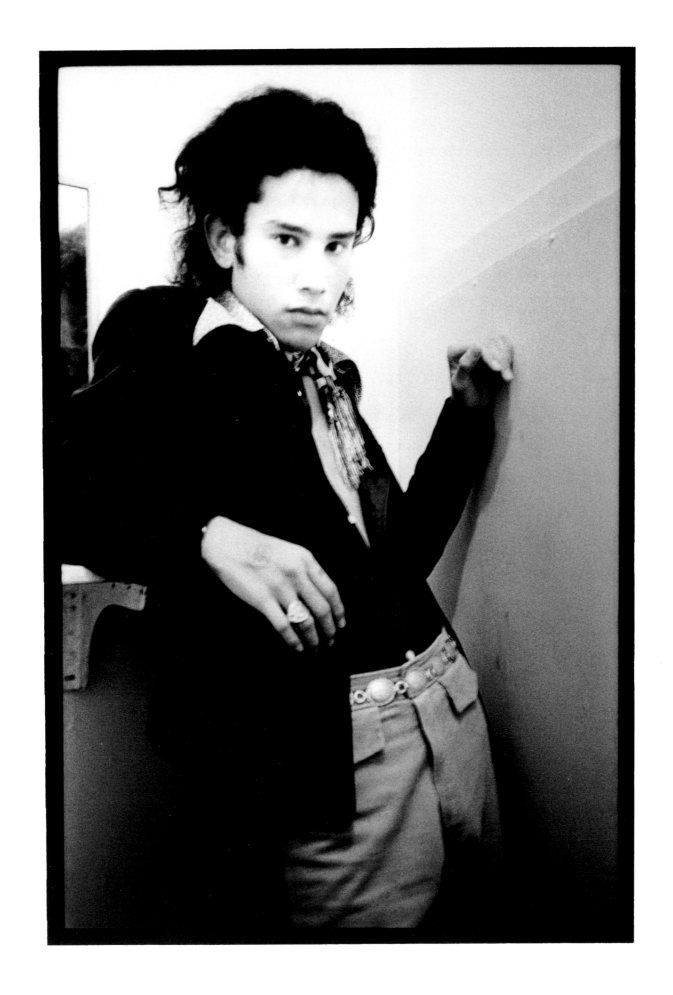

1: YOUNG MAN, TROUPER'S HALL, HOLLYWOOD, 1969

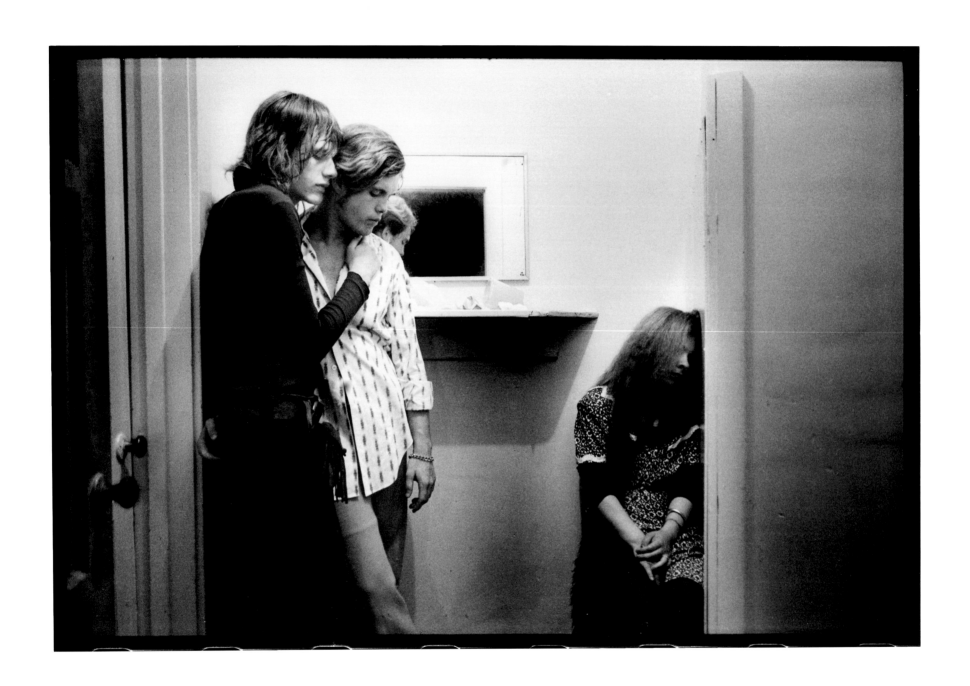

2: RESTROOM, TROUPER'S HALL, HOLLYWOOD, 1970

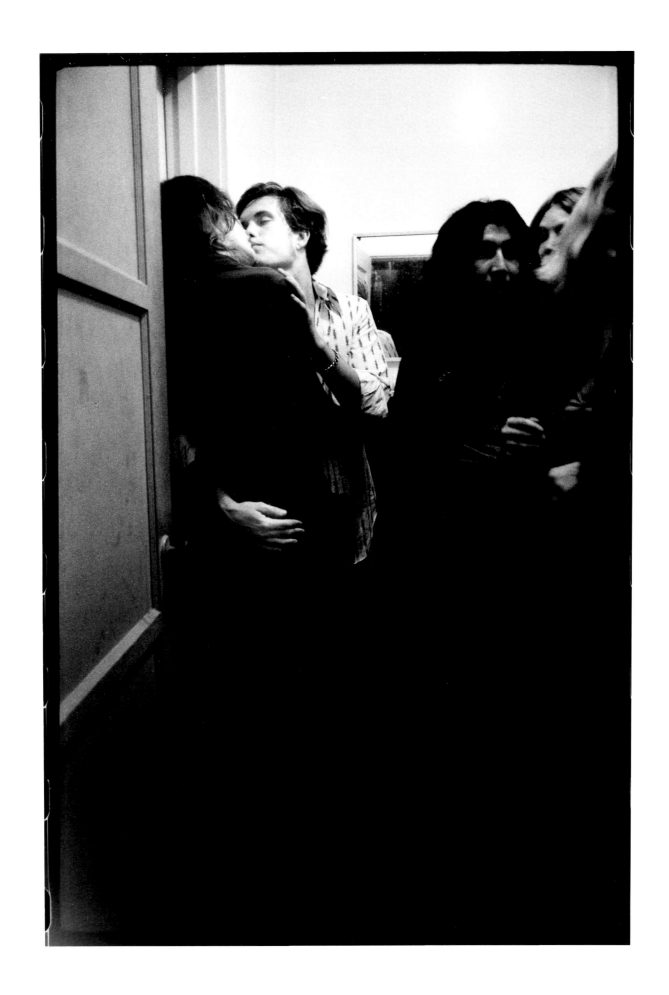

3: RESTROOM, TROUPER'S HALL, HOLLYWOOD, 1970

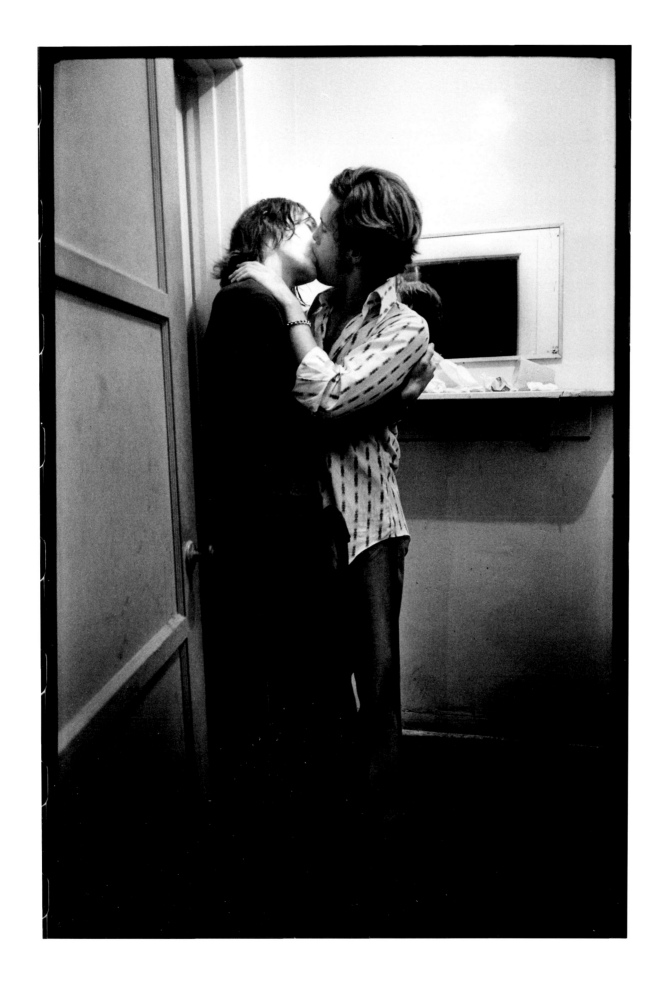

4: COUPLE KISSING, RESTROOM, TROUPER'S HALL, HOLLYWOOD, 1970

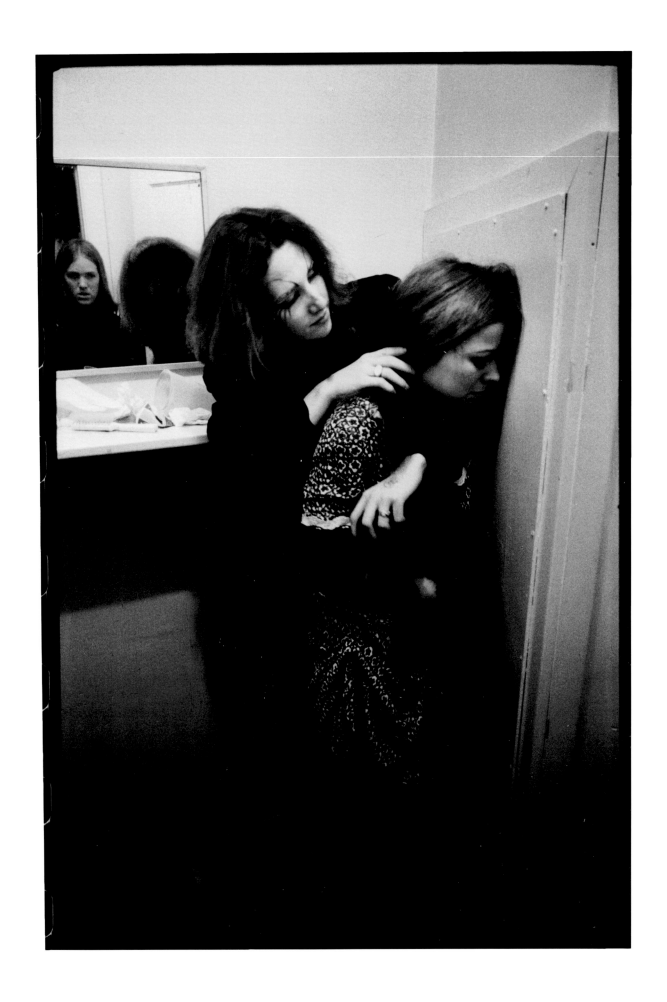

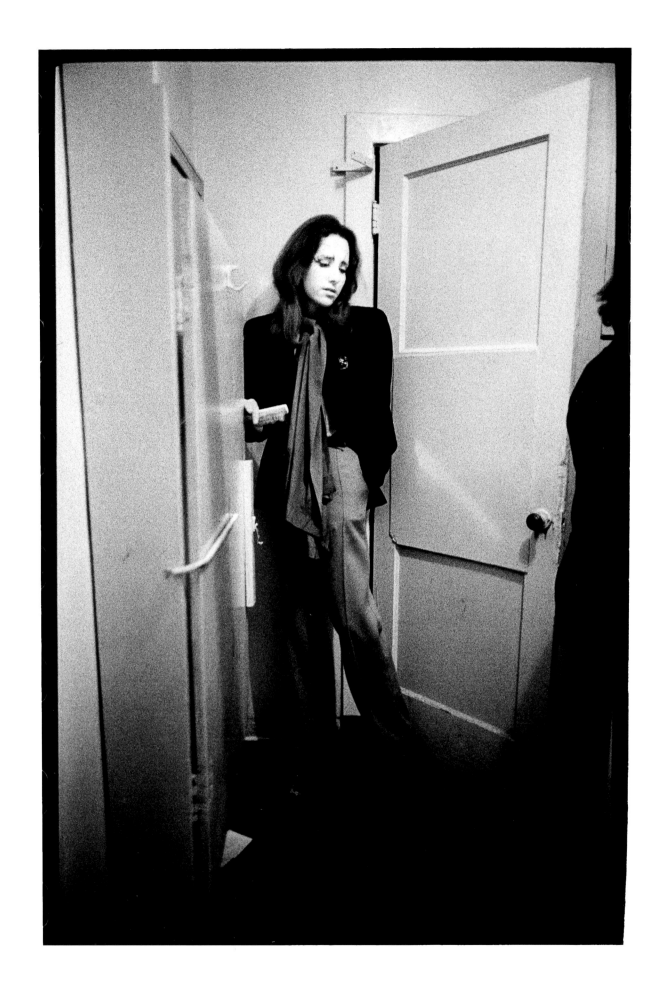

6: JIM, RESTROOM AT TROUPER'S HALL, HOLLYWOOD, 1970

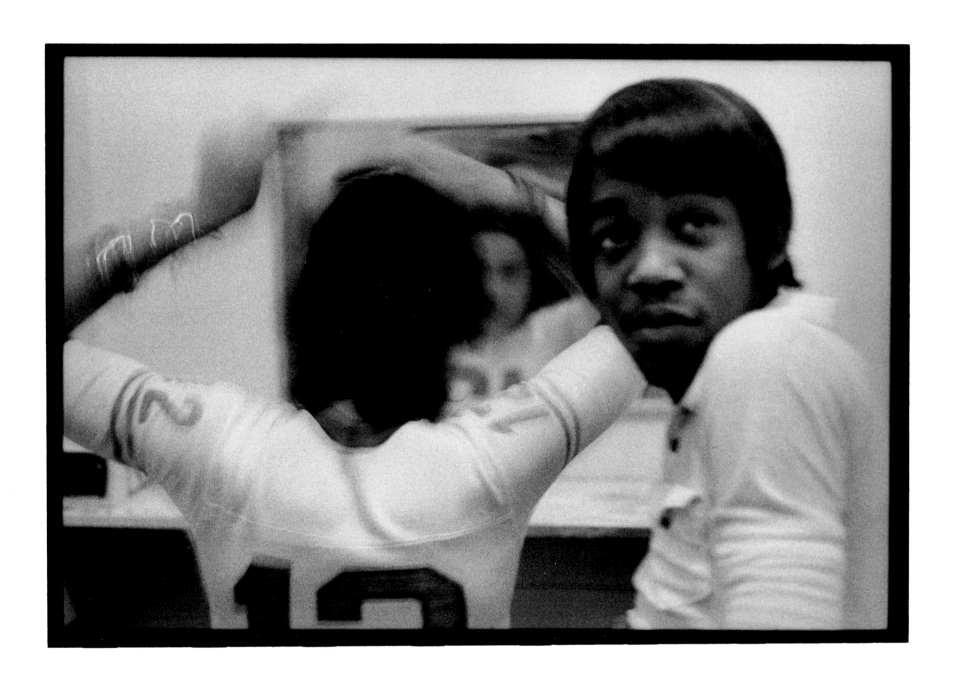

THE CHRISTOPHER STREET WEST PARADE

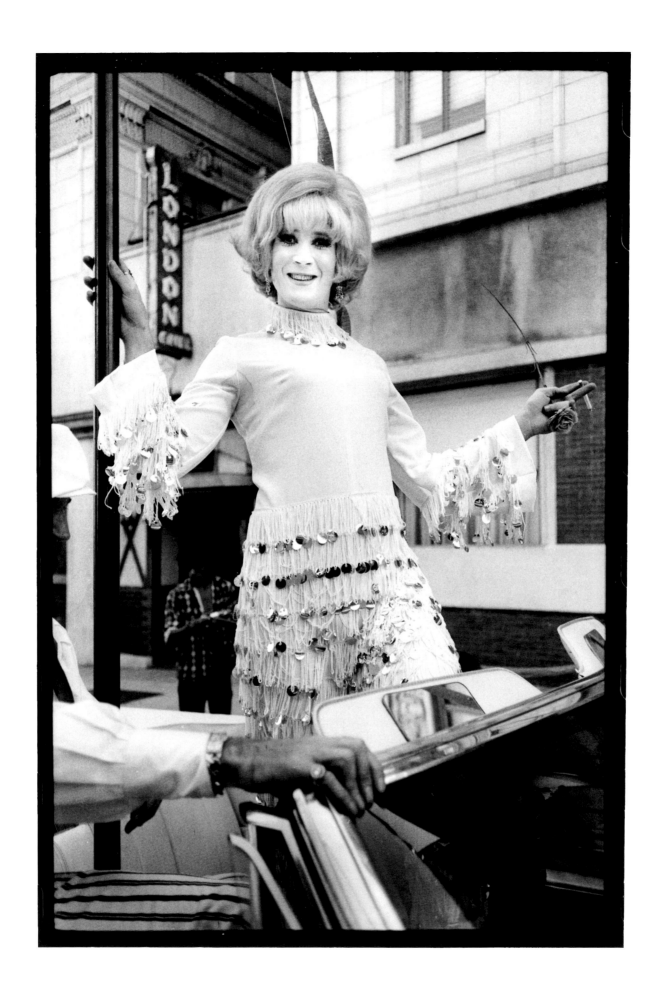

8: MAY DOLL, GAY LIBERATION PARADE, HOLLYWOOD, 1972

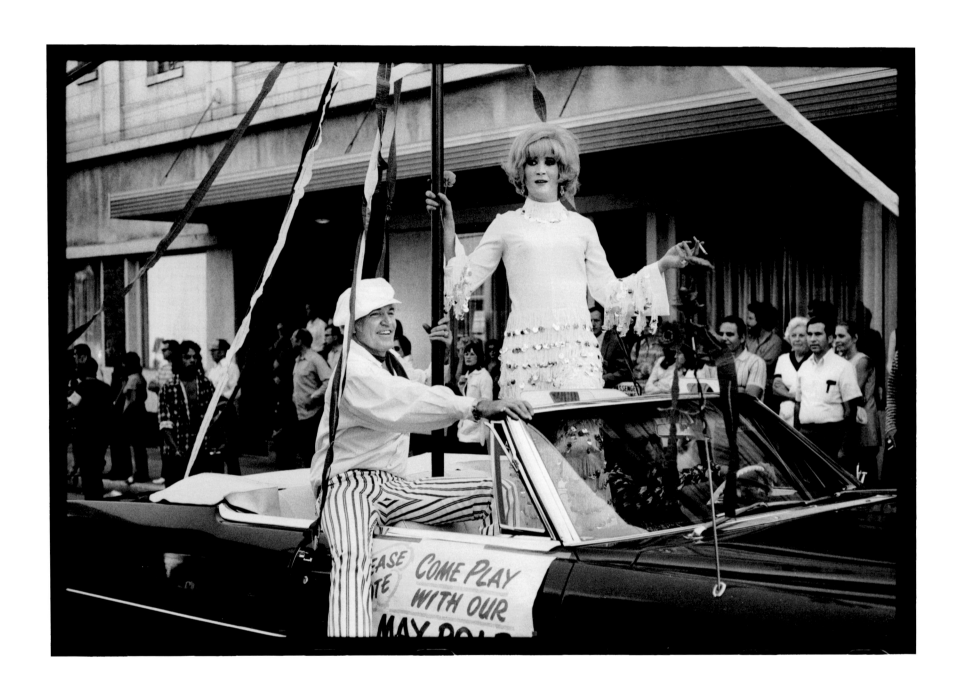

10: GAY LIBERATION PARADE, HOLLYWOOD, 1972

11: REVEREND TROY PERRY AT GAY LIBERATION PARADE, HOLLYWOOD, 1972

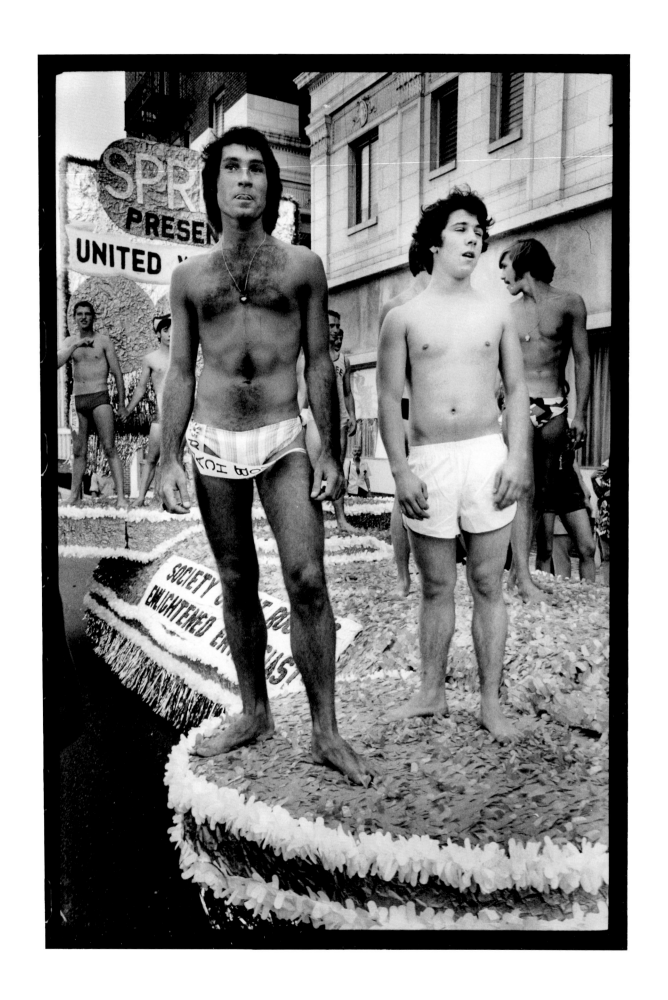

12: THE SPREE FLOAT, GAY LIBERATION PARADE, HOLLYWOOD, 1972

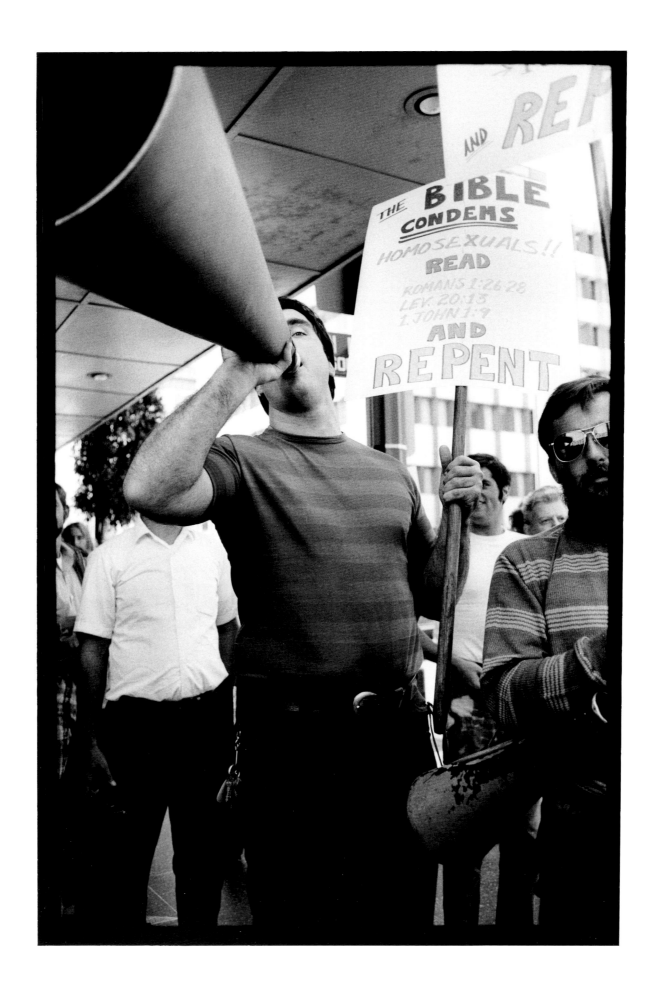

13: "THE BIBLE CONDEMNS HOMOSEXUALITY," GAY LIBERATION PARADE, HOLLYWOOD, 1972

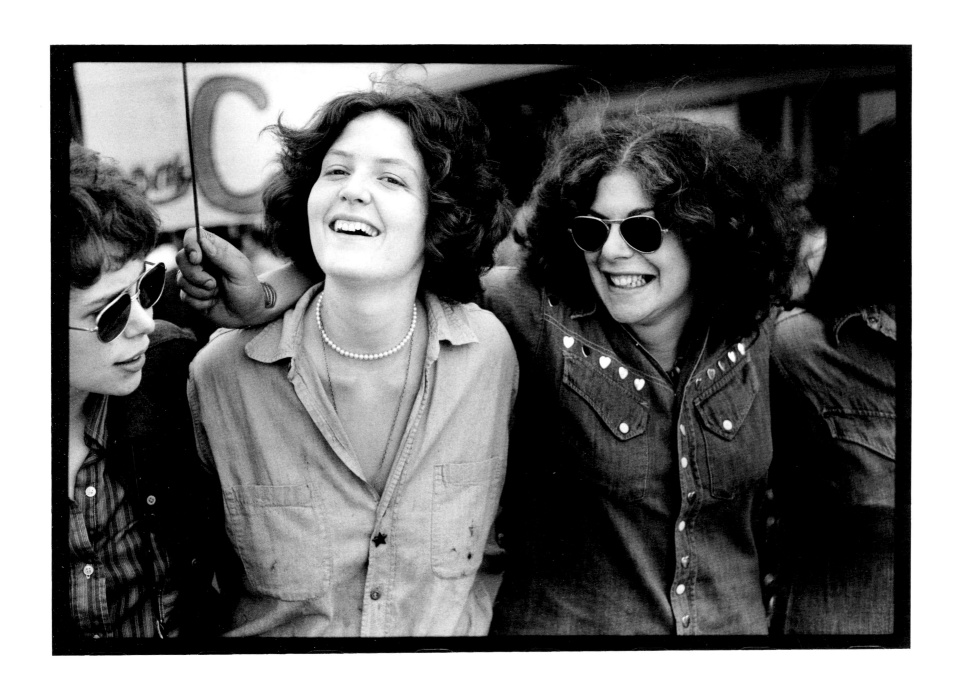

14: GAY LIBERATION PARADE, HOLLYWOOD, 1972

HOLLYWOOD

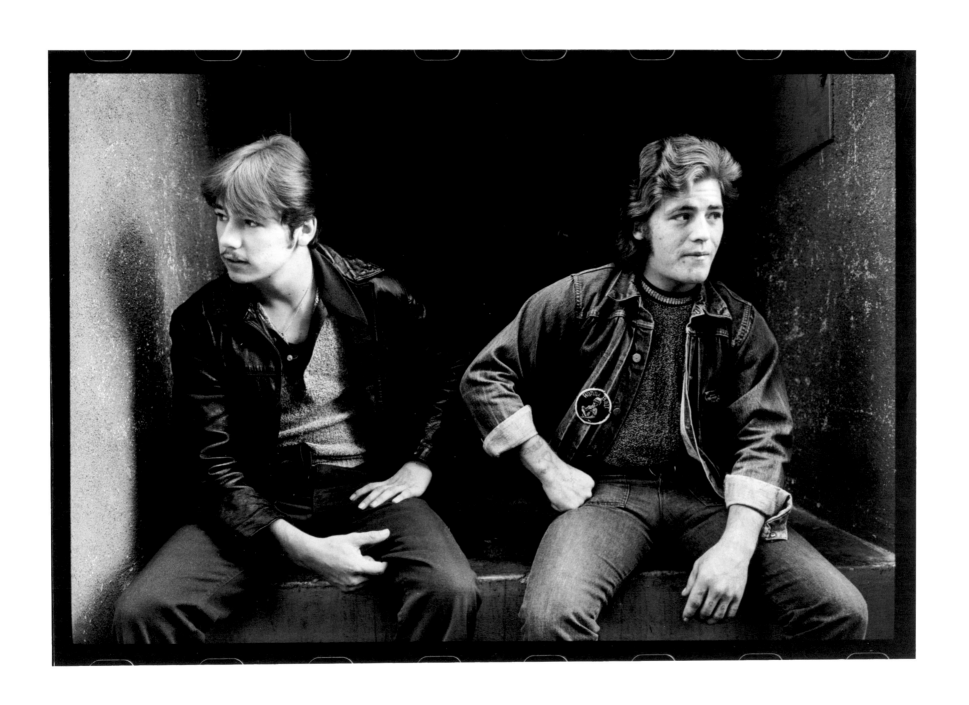

15: HUSTLERS, SELMA AVENUE, HOLLYWOOD, 1971

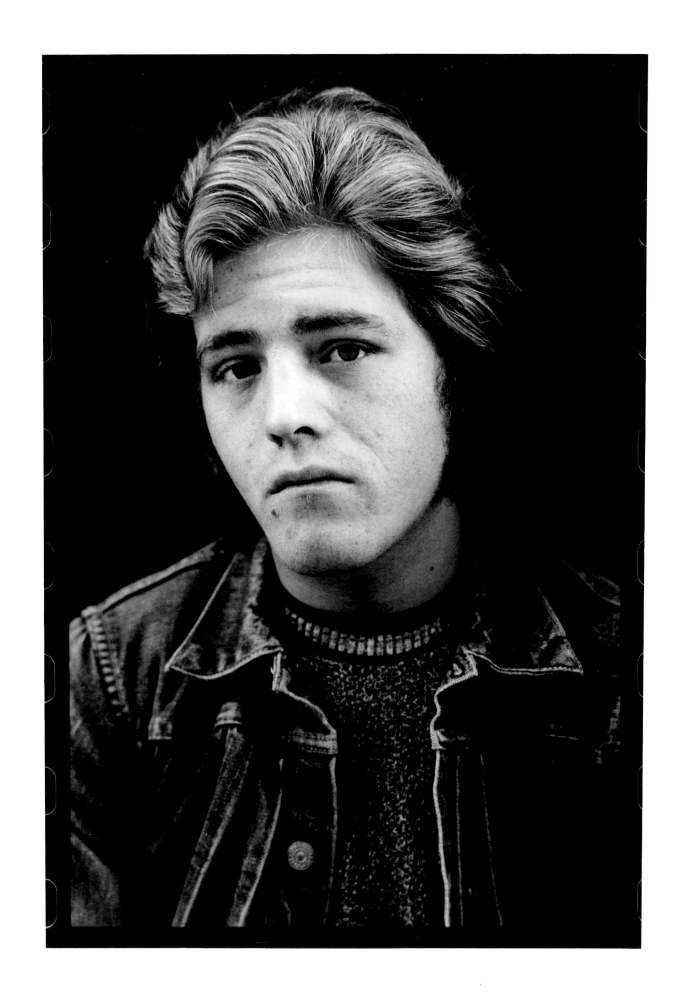

16: HUSTLER, SELMA AVENUE, HOLLYWOOD, 1971

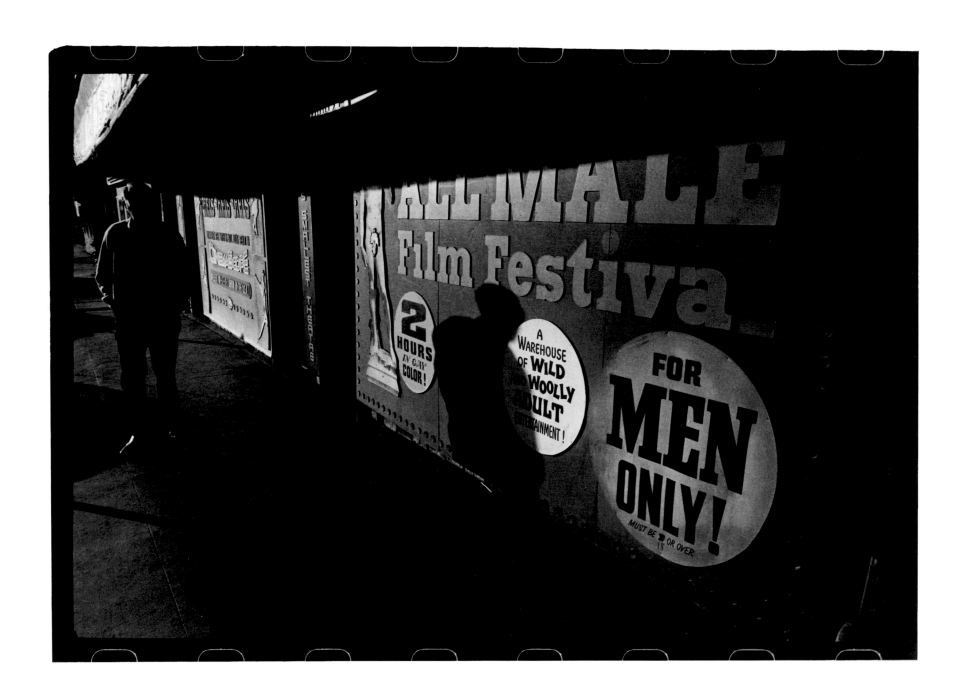

17: ALL-MALE FILM FESTIVAL, HOLLYWOOD, 1972

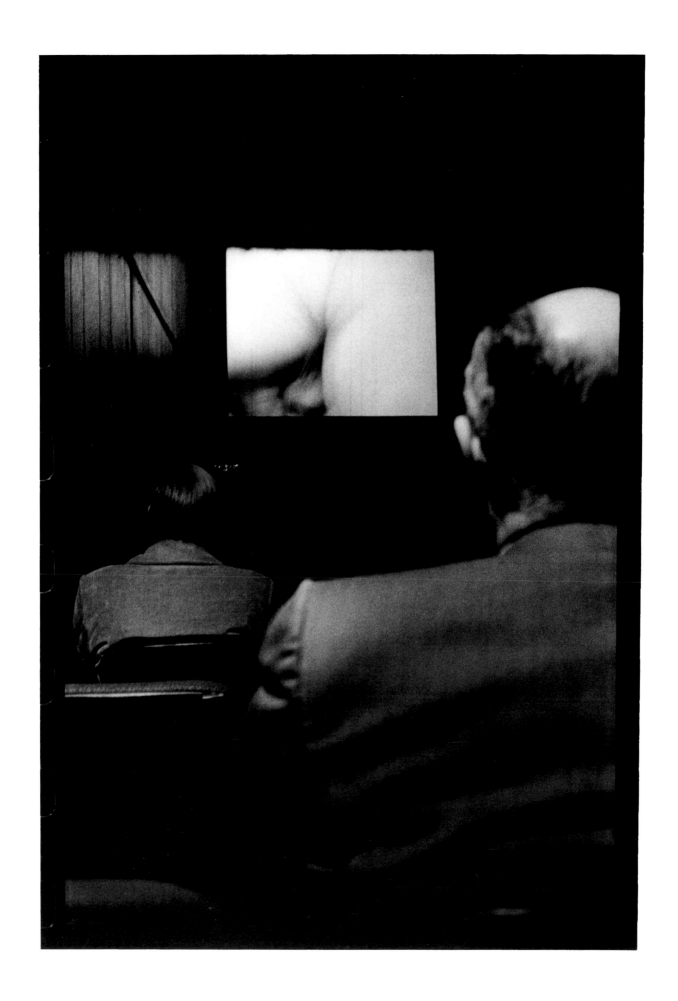

18: GAY CINEMA INTERIOR, HOLLYWOOD, 1970

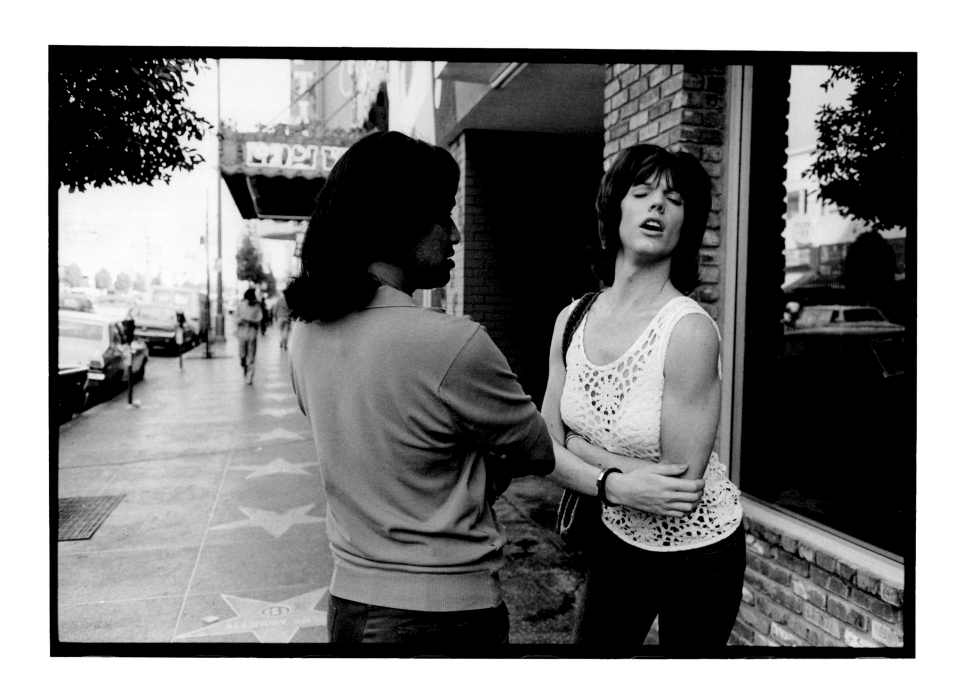

19: HUSTLER IN DRAG, HOLLYWOOD, 1971

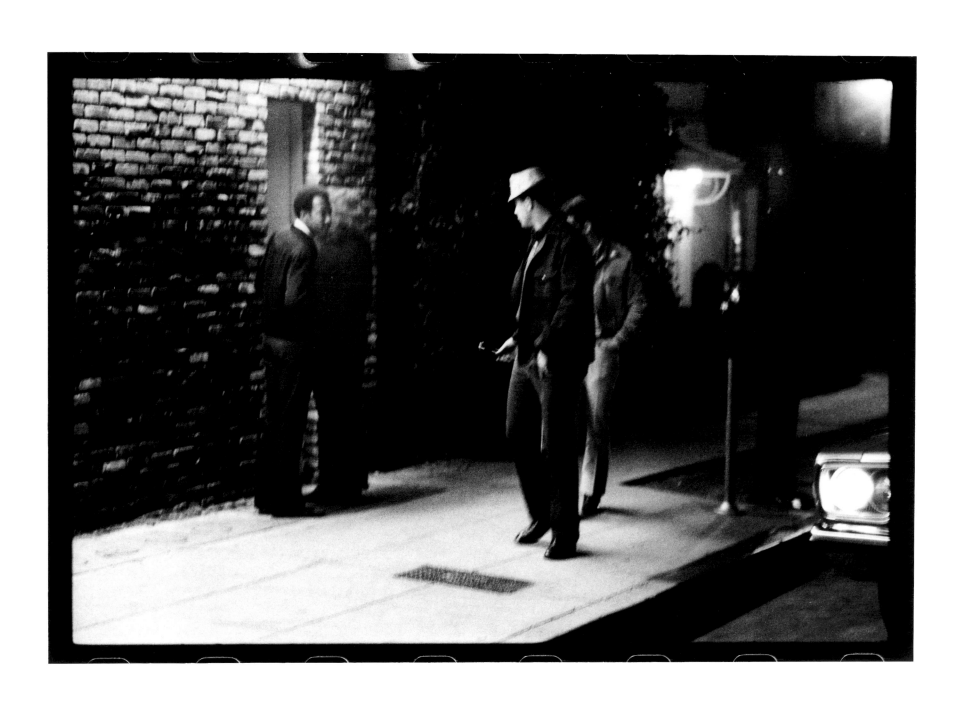

20: VICE POLICE HARASSING GAYS, HOLLYWOOD, 1970

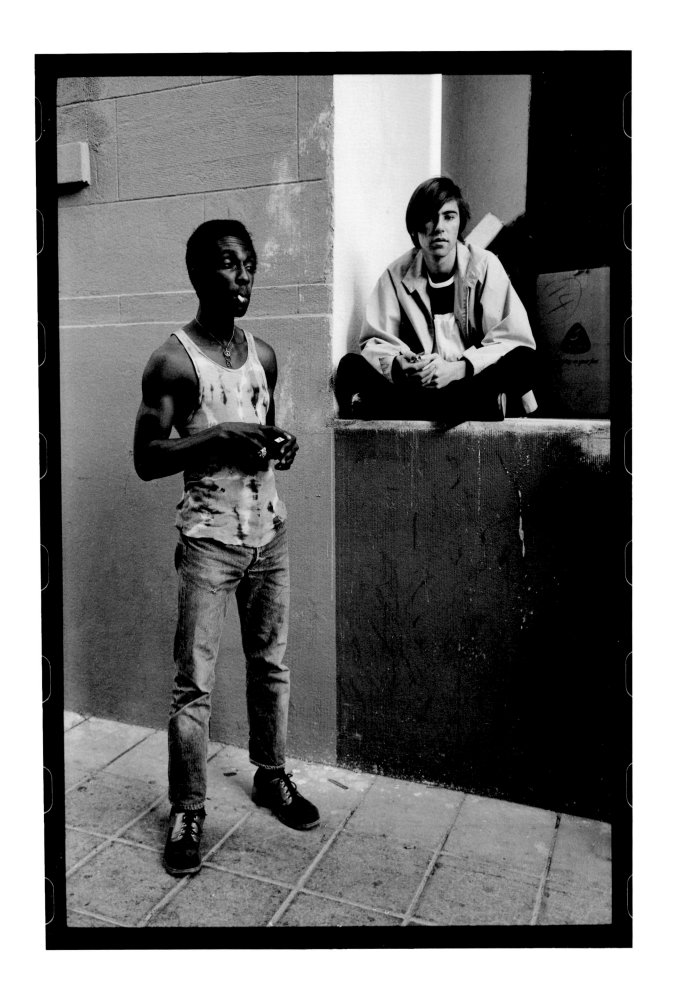

21: YOUNG HUSTLERS, SELMA AVENUE, HOLLYWOOD, 1971

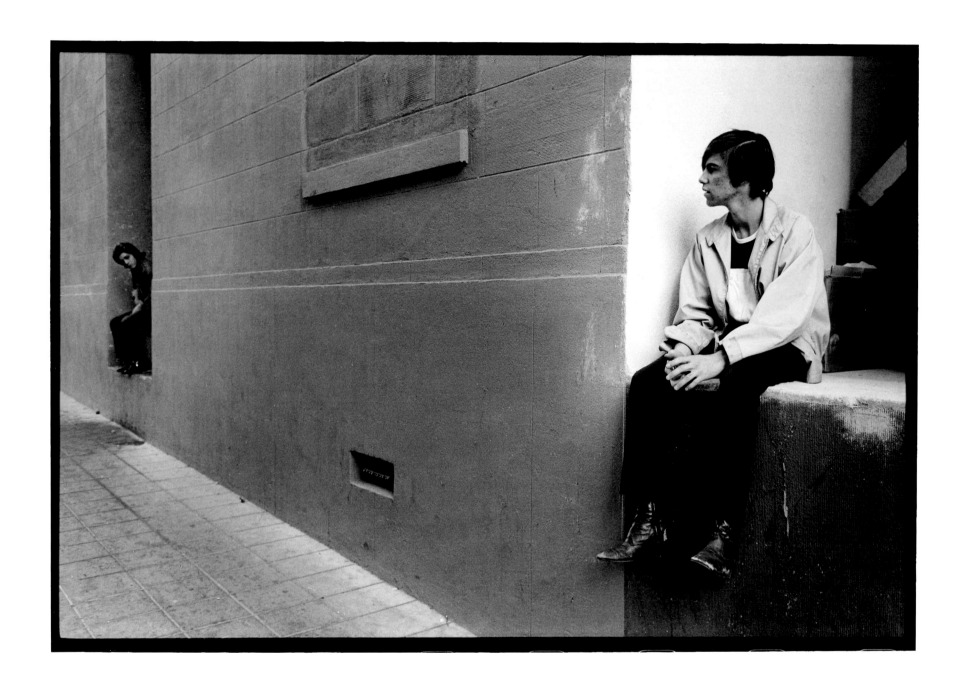

22: YOUNG HUSTLERS, SELMA AVENUE, HOLLYWOOD, 1971

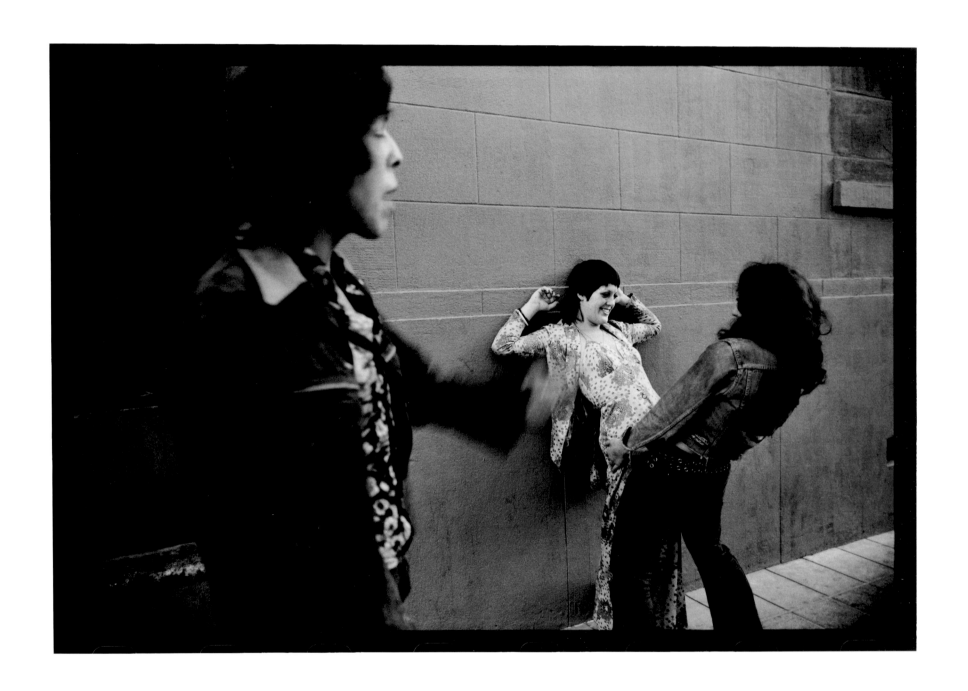

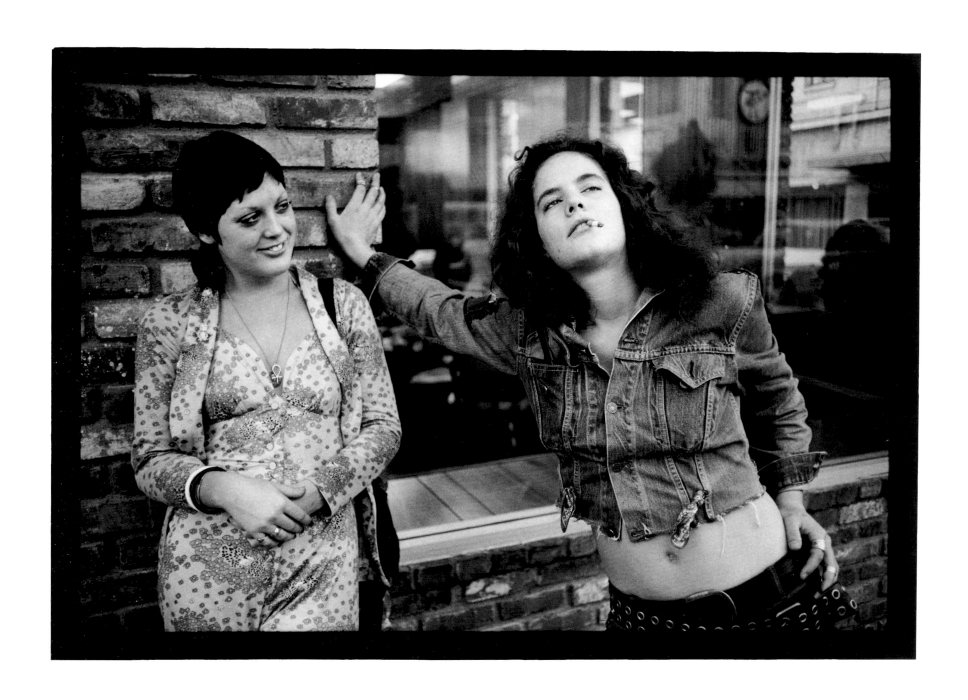

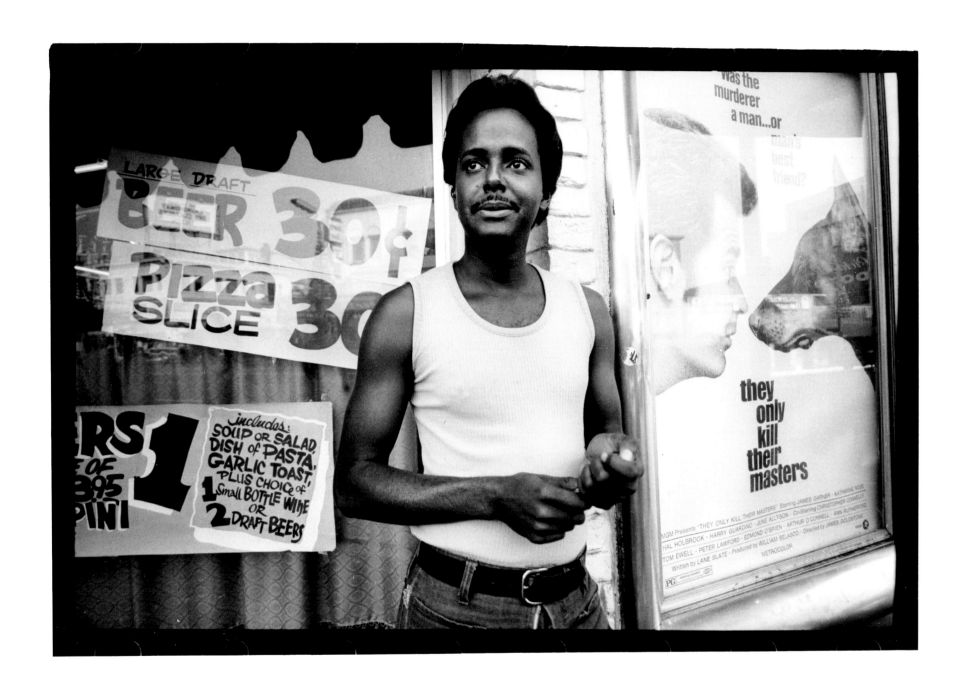

FEMALE IMPERSONATORS

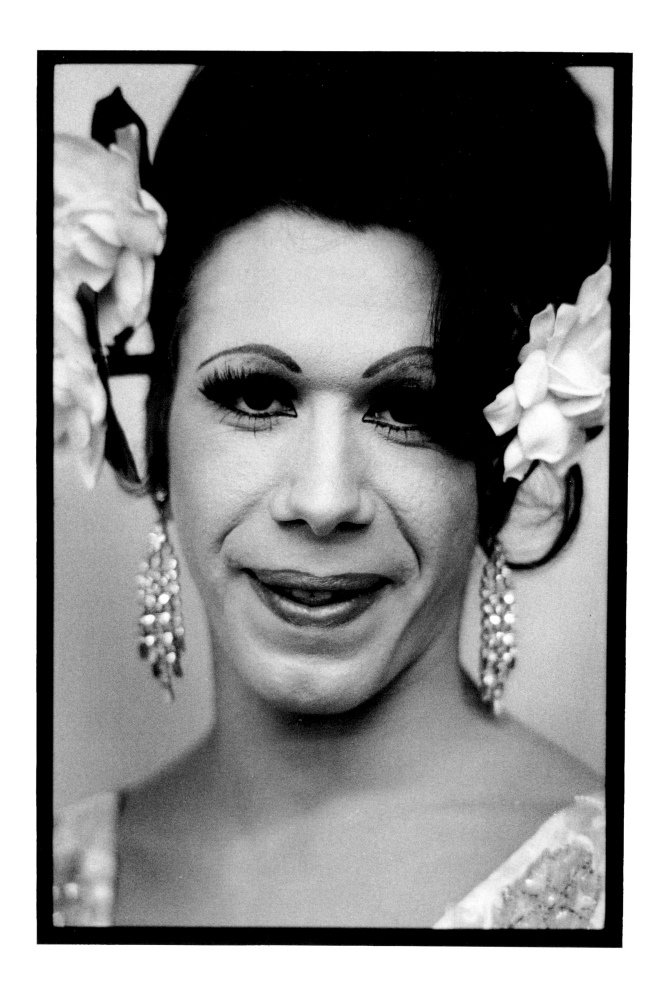

26: BILLIE HOLIDAY, DRAG QUEEN BALL, LONG BEACH, 1971

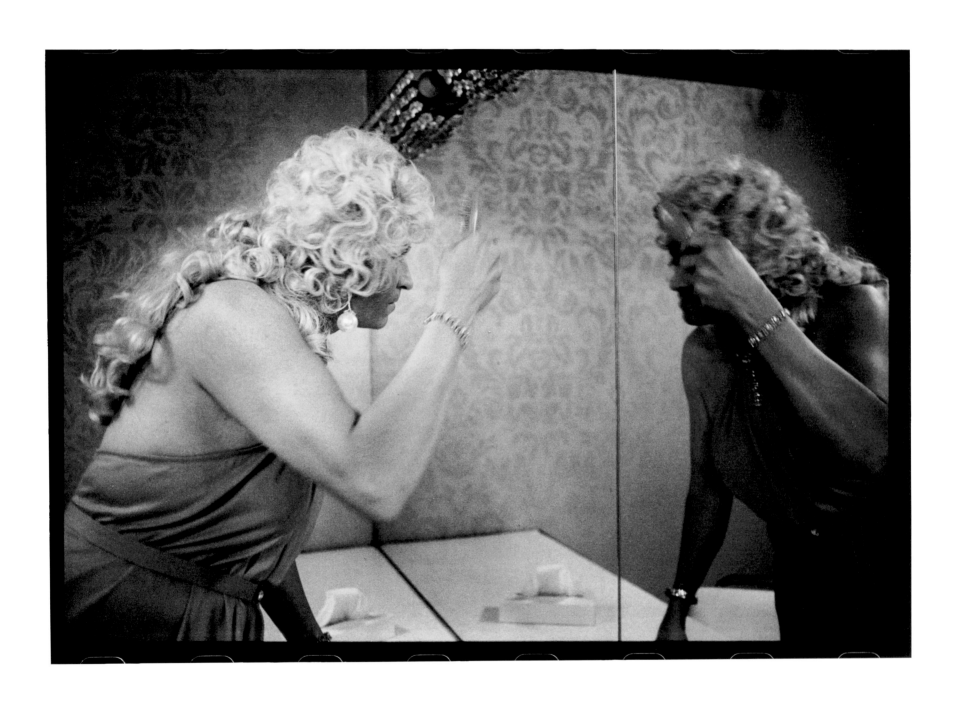

27: DRAG QUEEN, LONG BEACH, 1971

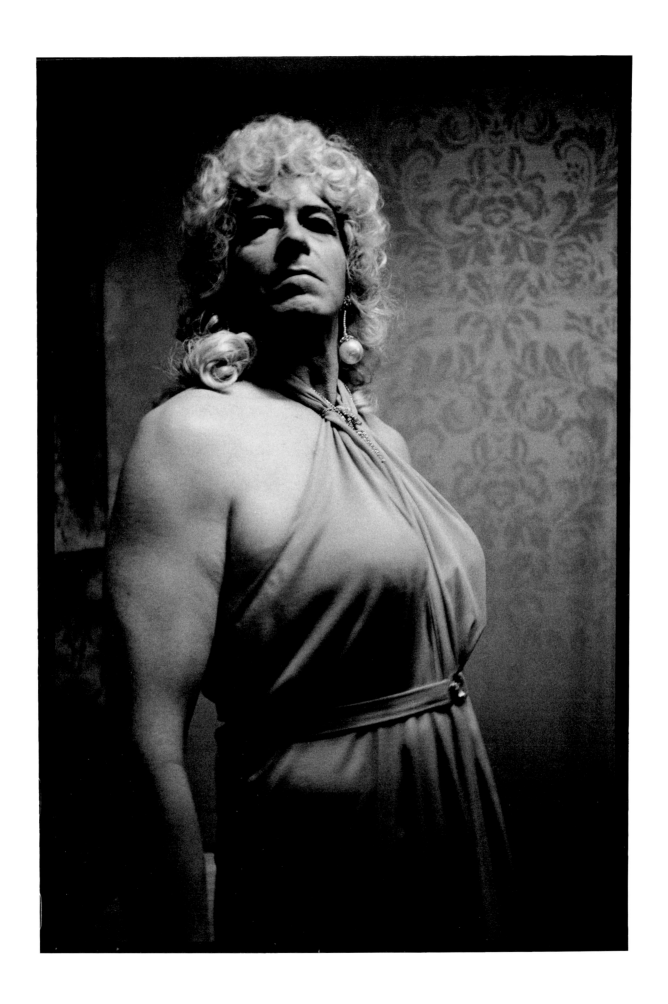

28: DRAG QUEEN, LONG BEACH, 1971

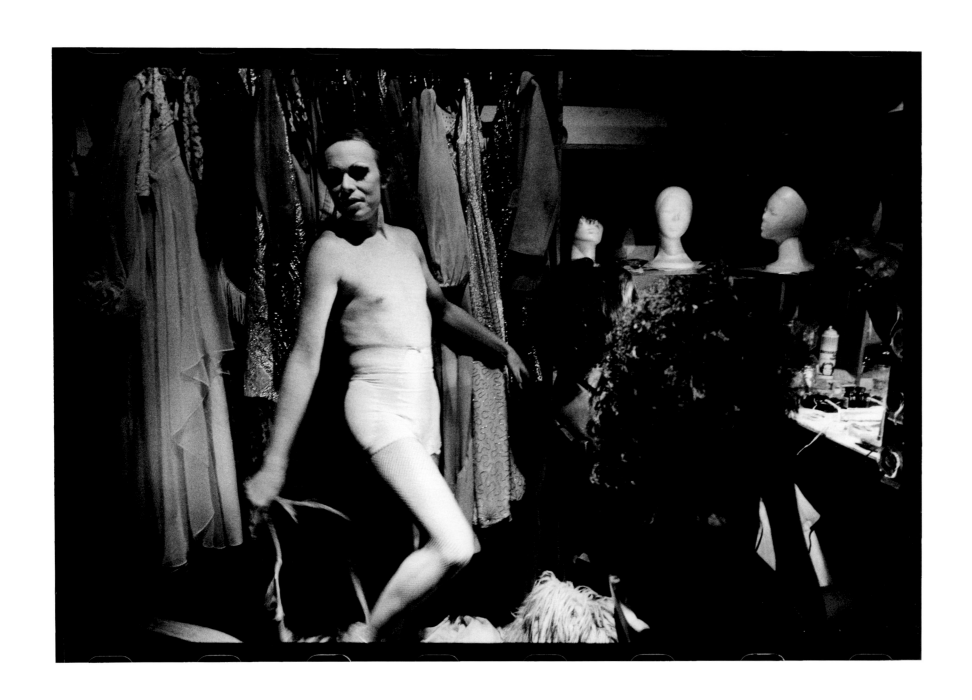

29: DRESSING ROOM, "C'EST LA VIE" CLUB, NORTH HOLLYWOOD, 1972

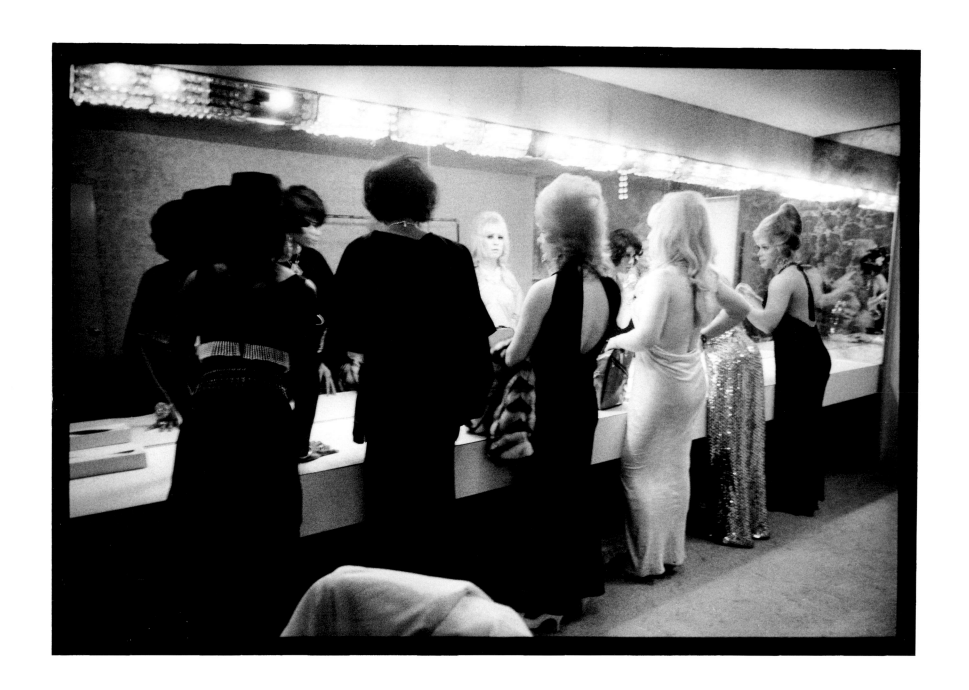

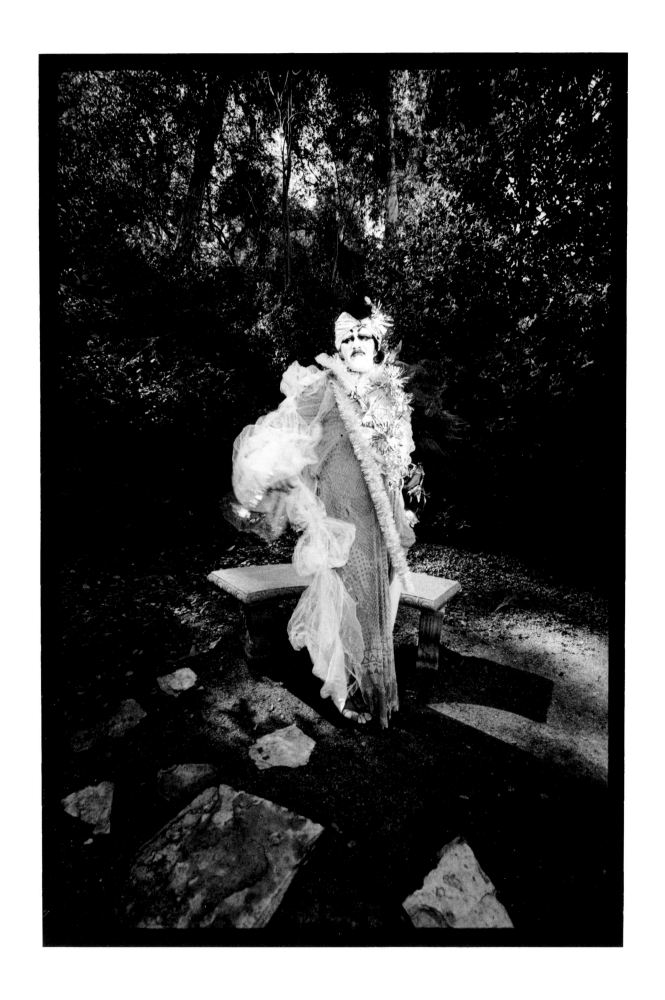

31: CYCLONA, IN THE GARDEN, LOS ANGELES, 1971

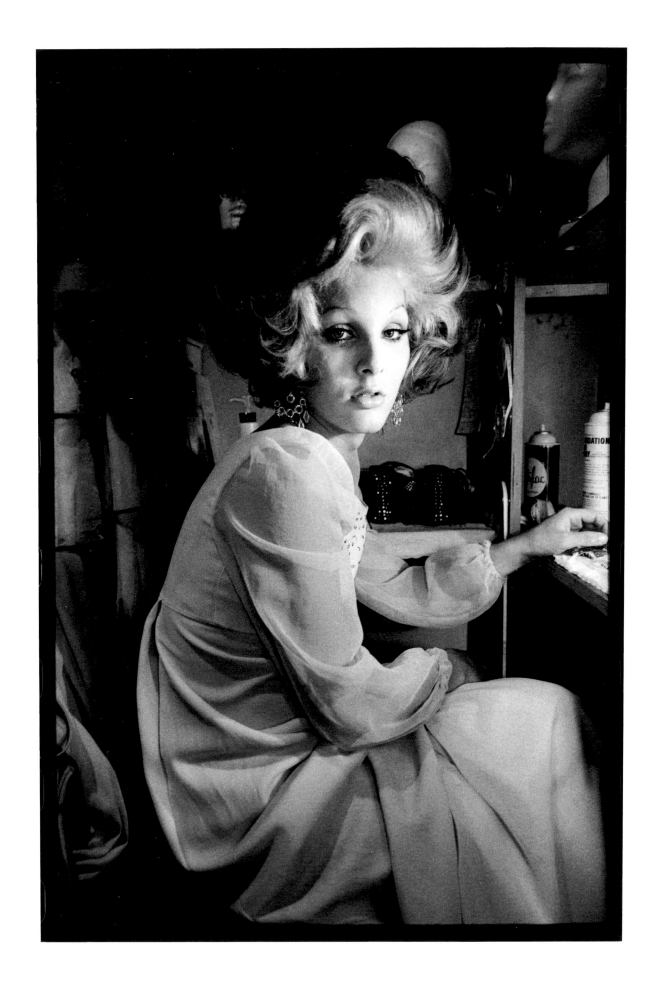

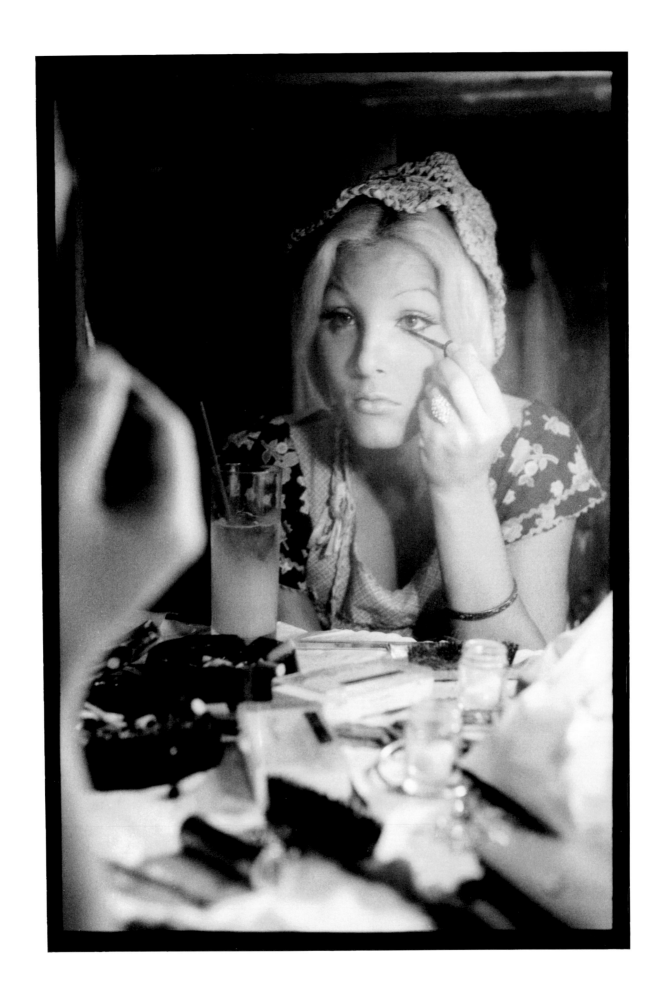

33: MICHELLE, "C'EST LA VIE" CLUB, NORTH HOLLYWOOD, 1972

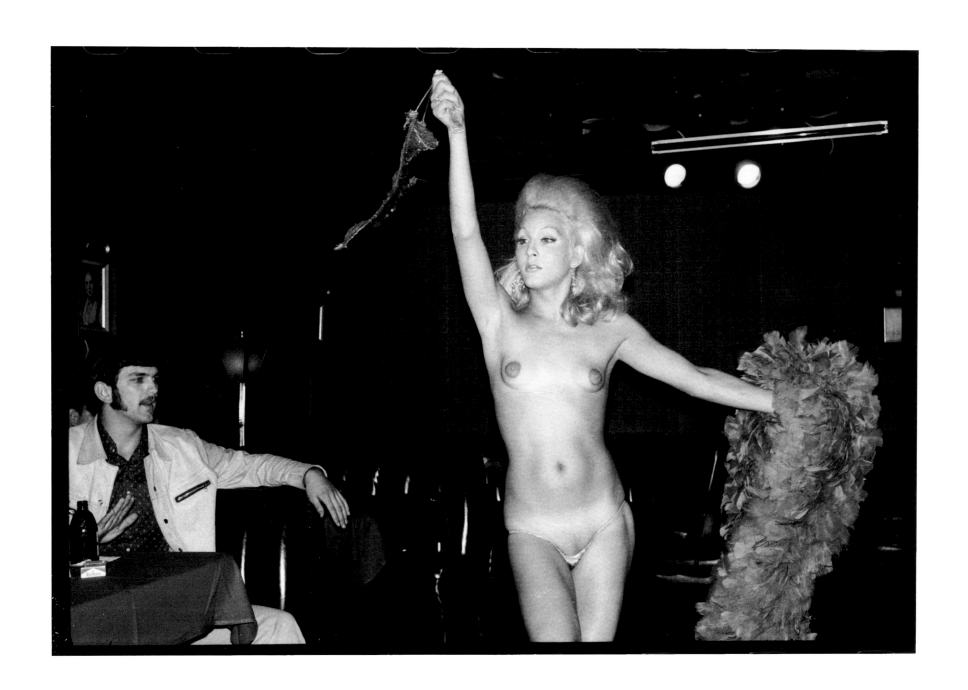

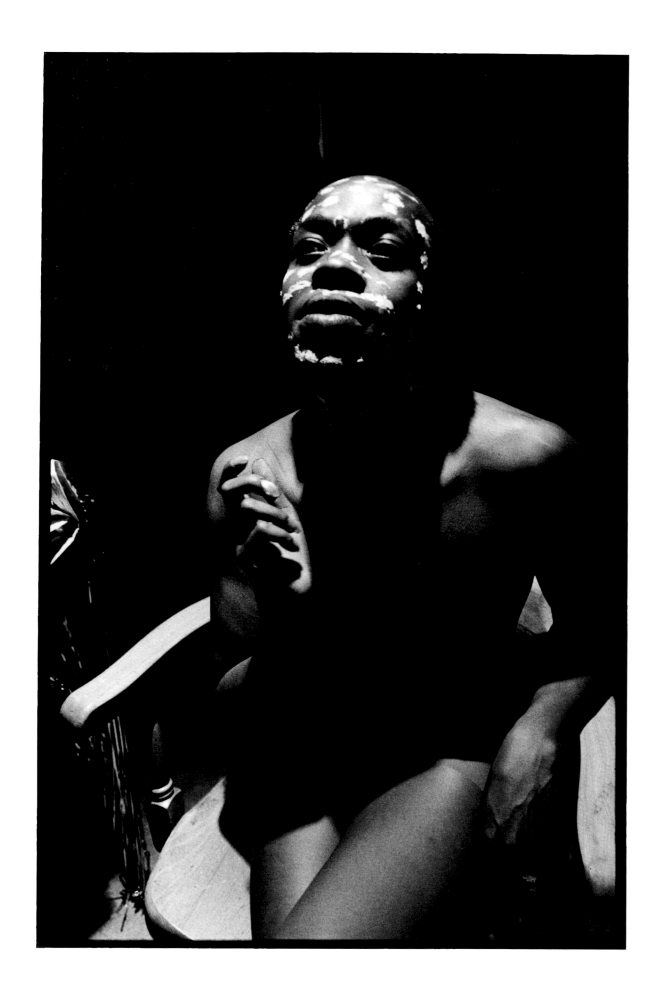

35: PUTTING ON MAKE-UP, "C'EST LA VIE" CLUB, NORTH HOLLYWOOD, 1972

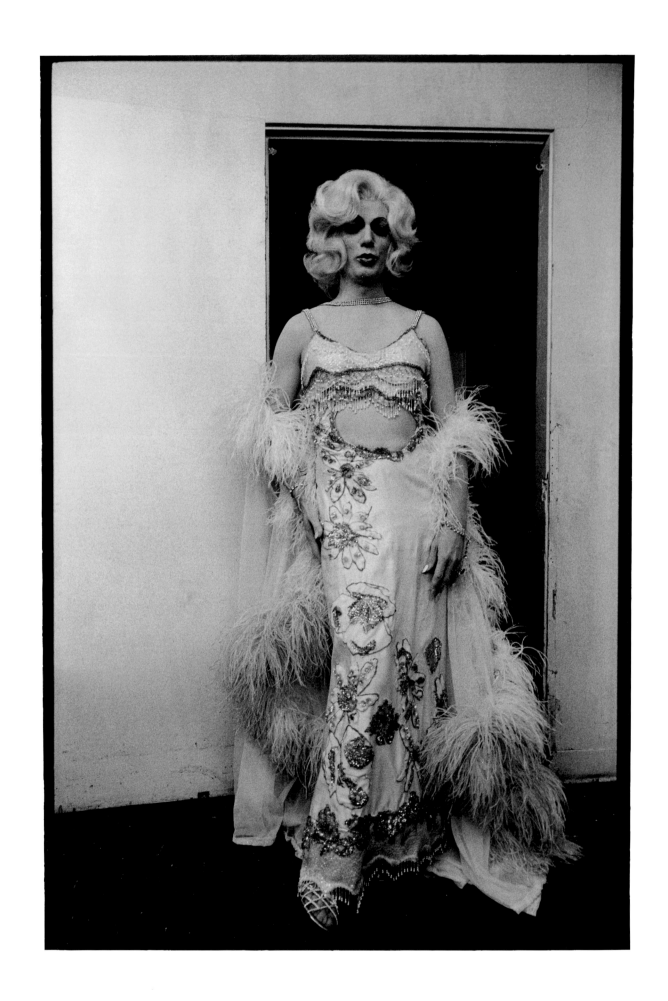

36: JEAN HARLOW, DRAG QUEEN BALL, LONG BEACH, 1971

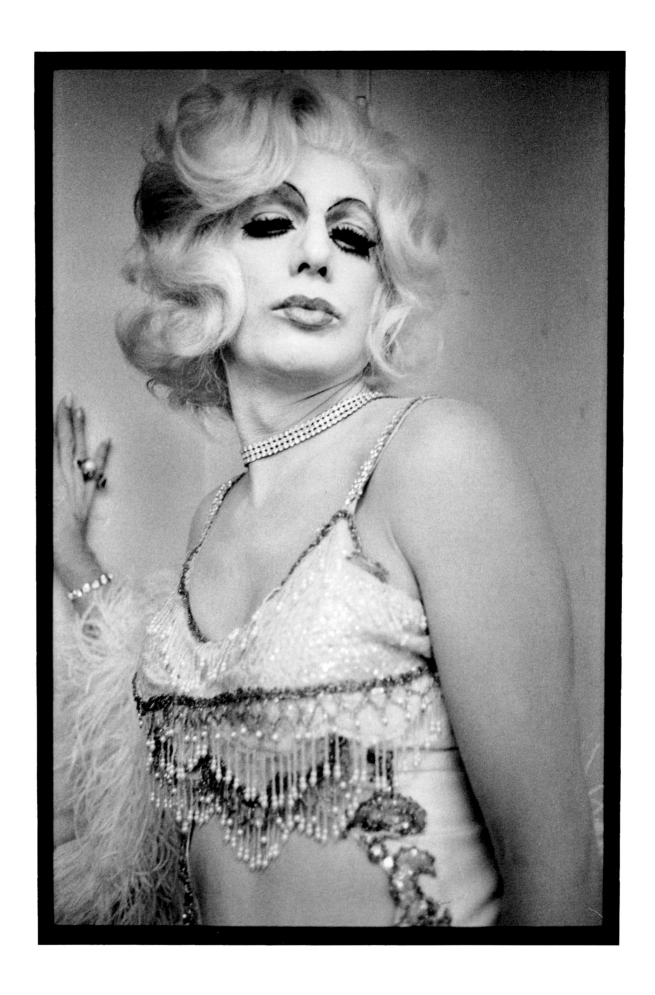

37: JEAN HARLOW, DRAG QUEEN BALL, LONG BEACH, 1971

PORTRAITS

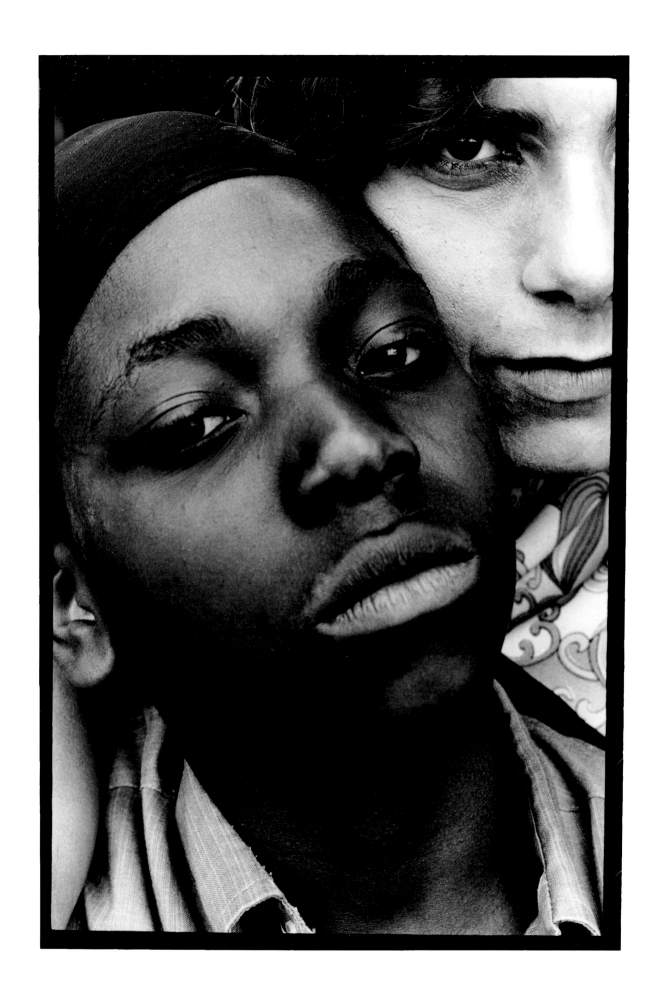

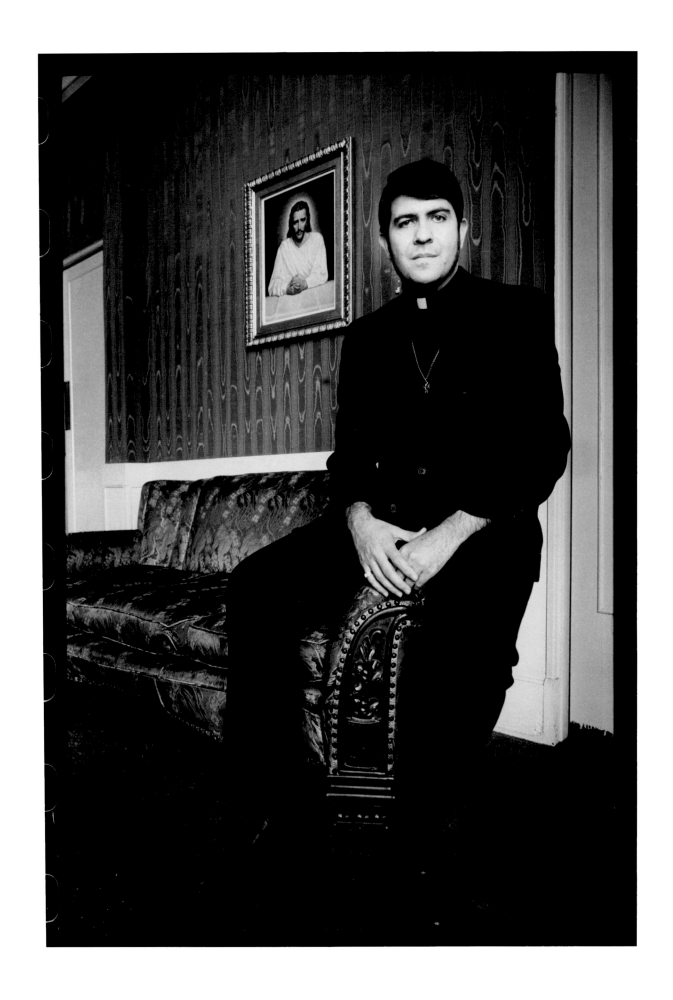

39: THE REVEREND TROY PERRY, GAY ACTIVIST, LOS ANGELES, 1973

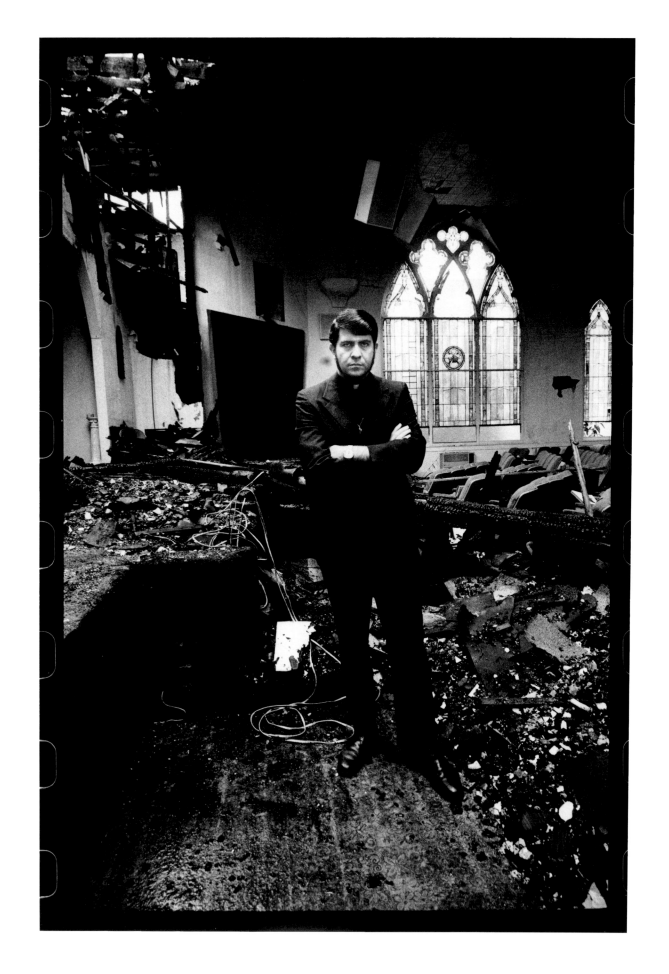

40: THE REVEREND TROY PERRY, GAY ACTIVIST, IN HIS
BURNT DOWN CHURCH, LOS ANGELES, 1973

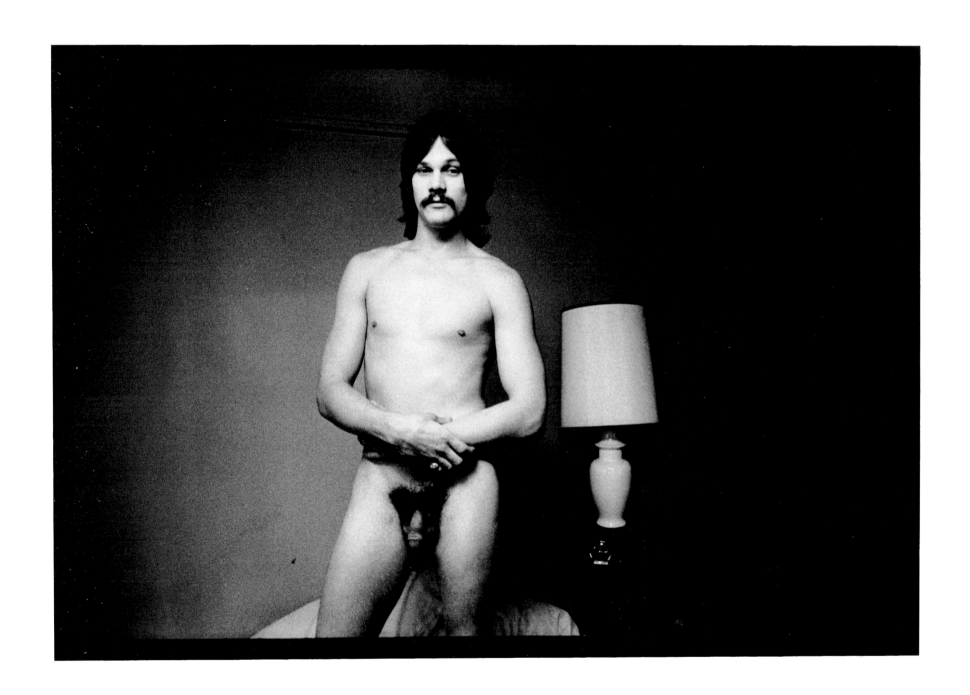

11: DAN, HUSTLER, BURBANK, 1970

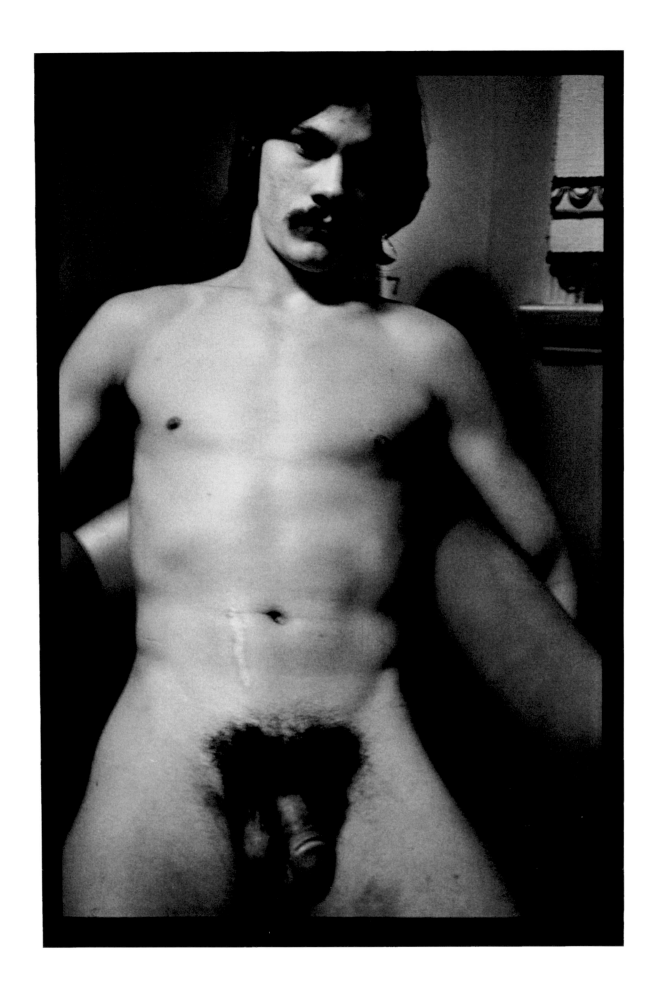

42: DAN, HUSTLER, BURBANK, 1970

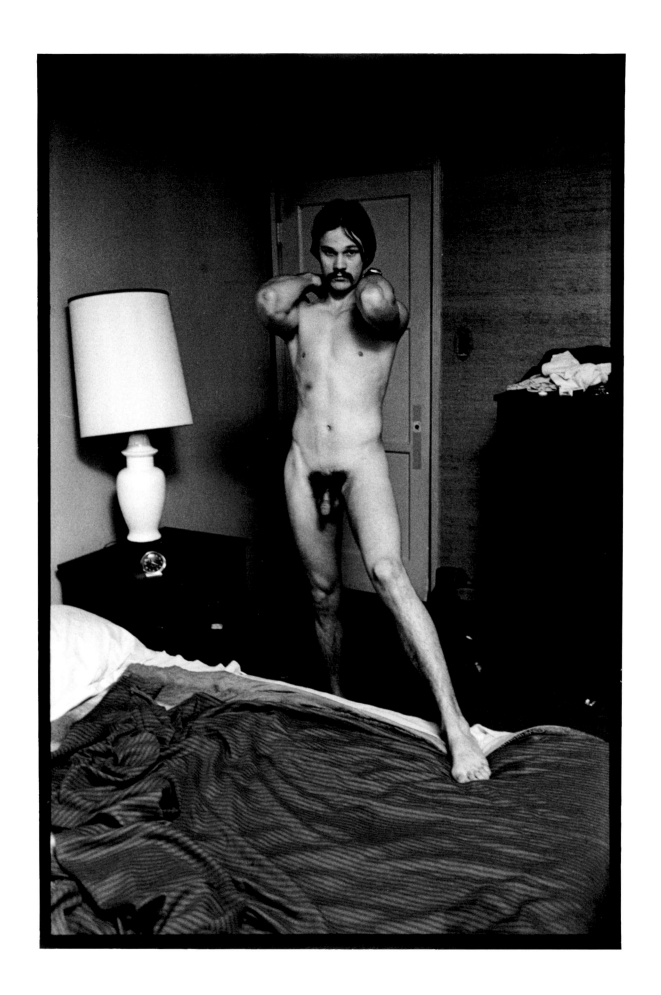

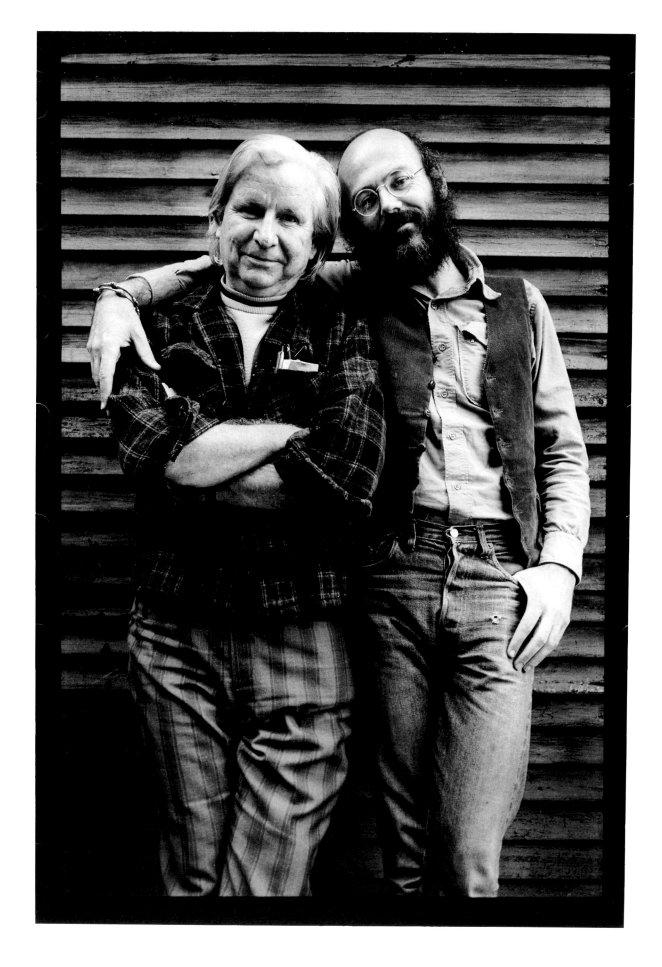

44: DON KILHEFNER AND MORRIS KIGHT AT THE GAY COMMUNITY
SERVICES CENTER, LOS ANGELES, 1972

45: COUPLE IN FRONT OF CHURCH, LOS ANGELES, 1970

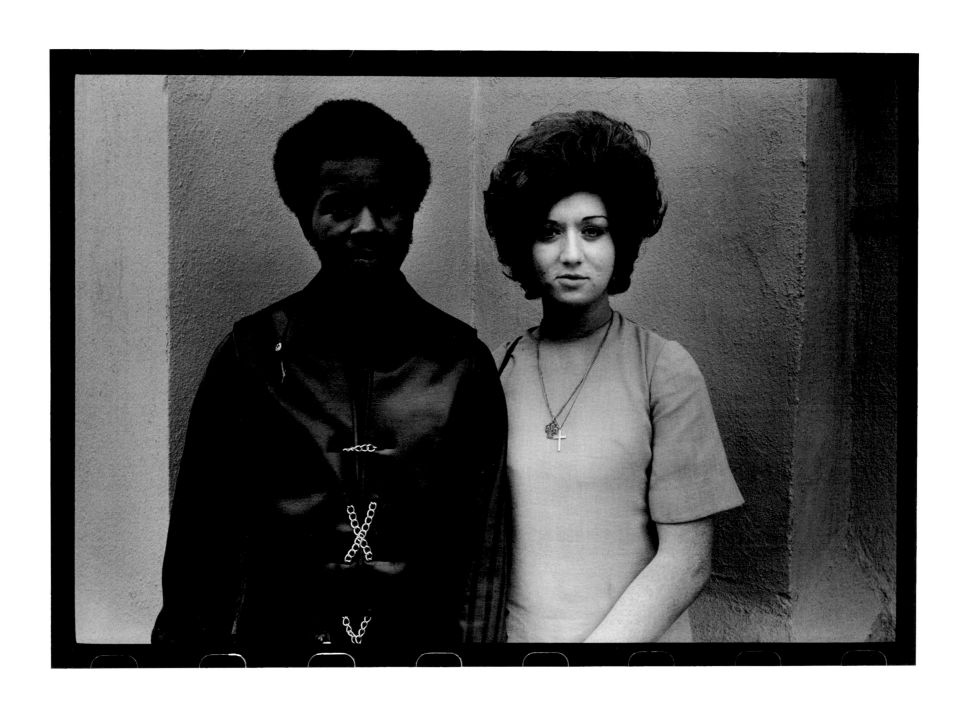

16: COUPLE IN FRONT OF CHURCH, LOS ANGELES, 1970

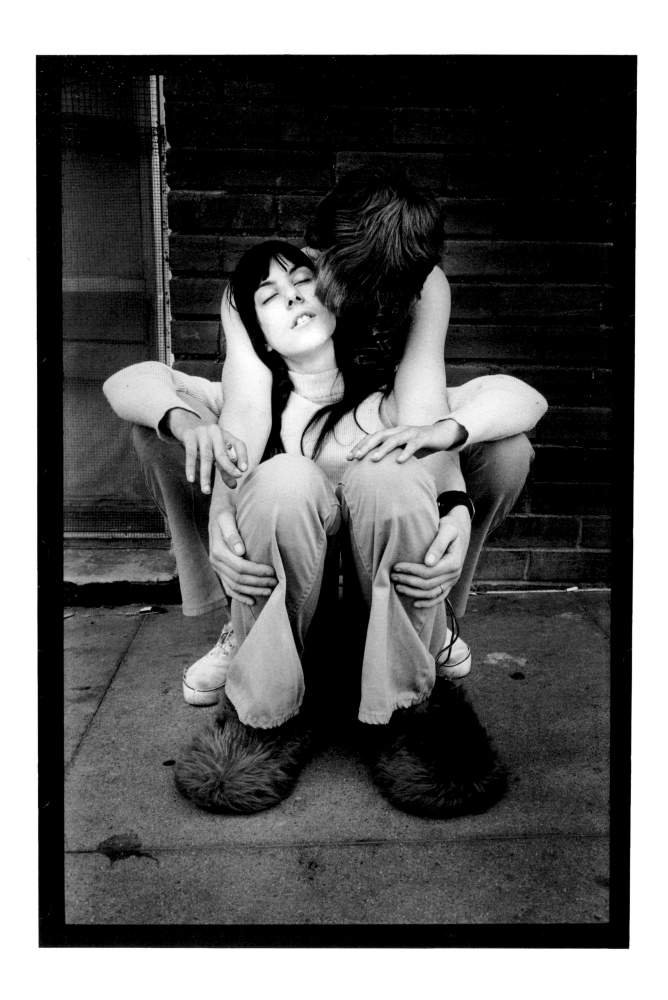

47: BOBBIE AND LINDA, VENICE, 1970

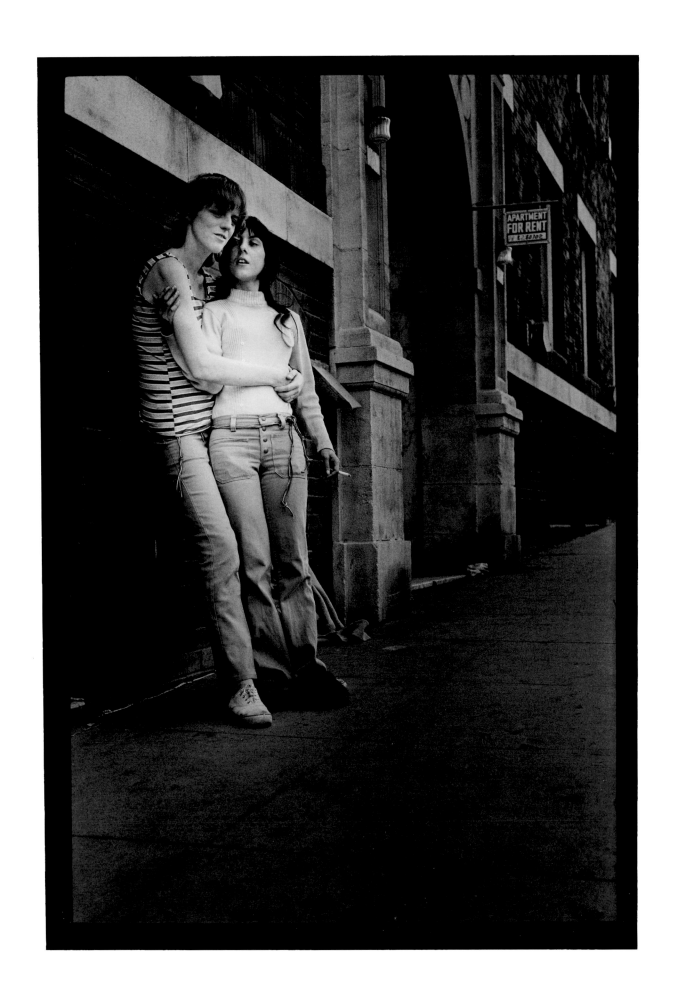

48: BOBBIE AND LINDA IN FRONT OF THEIR APARTMENT, VENICE, 1970

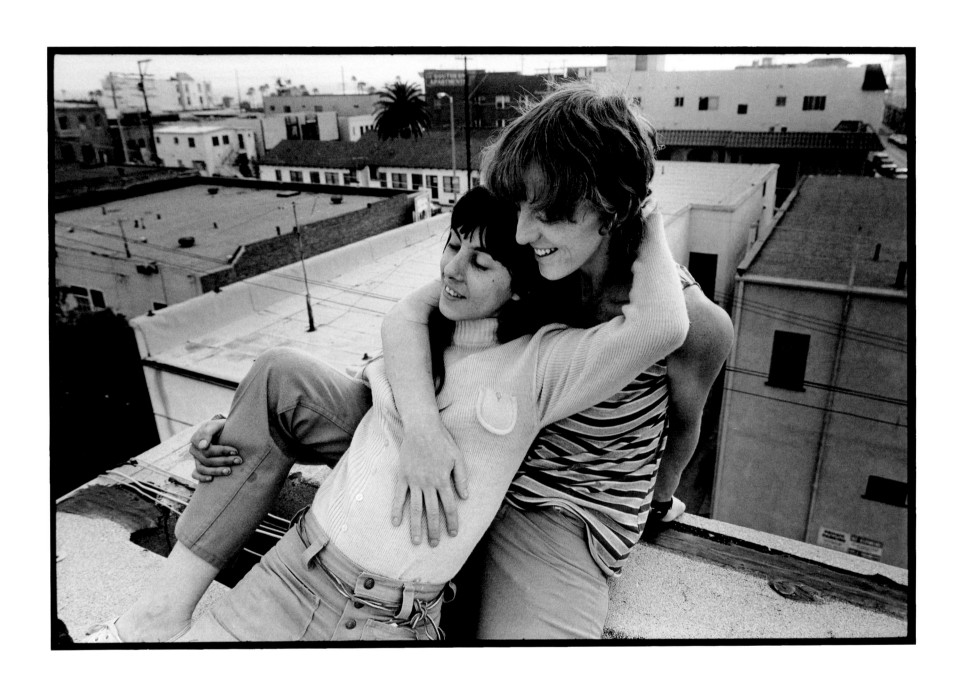

49: BOBBIE AND LINDA ON ROOFTOP, VENICE, 1970

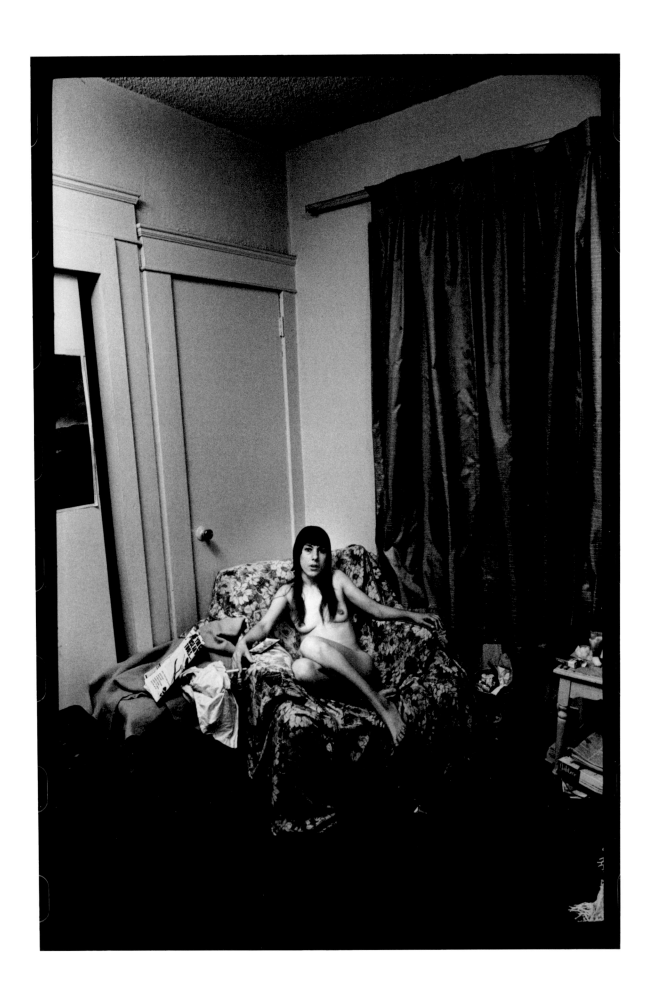

50: BOBBIE, VENICE, 1970

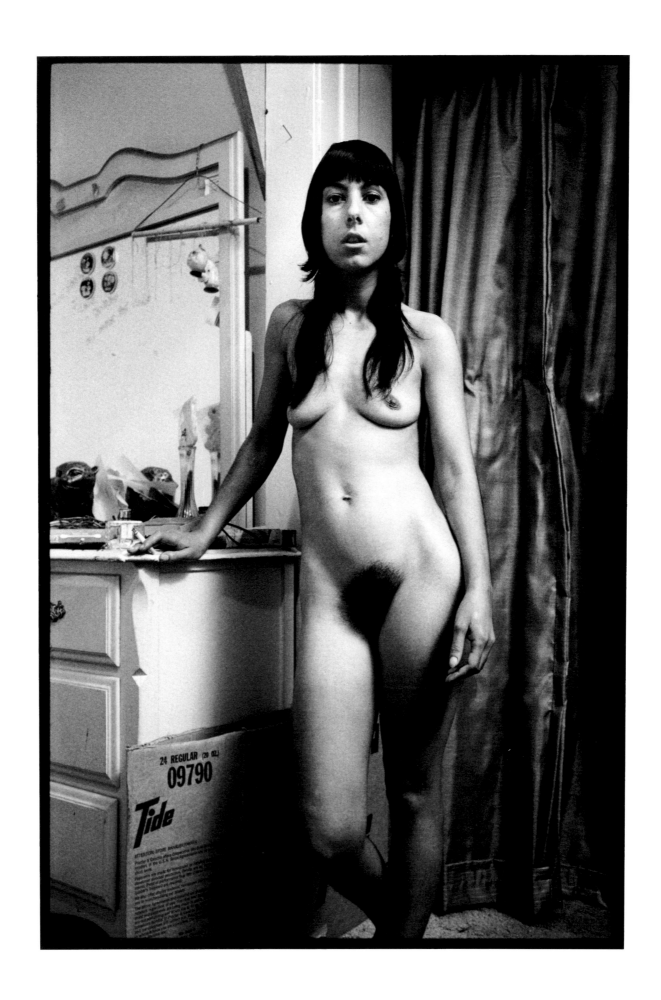

51: BOBBIE, VENICE, 1970

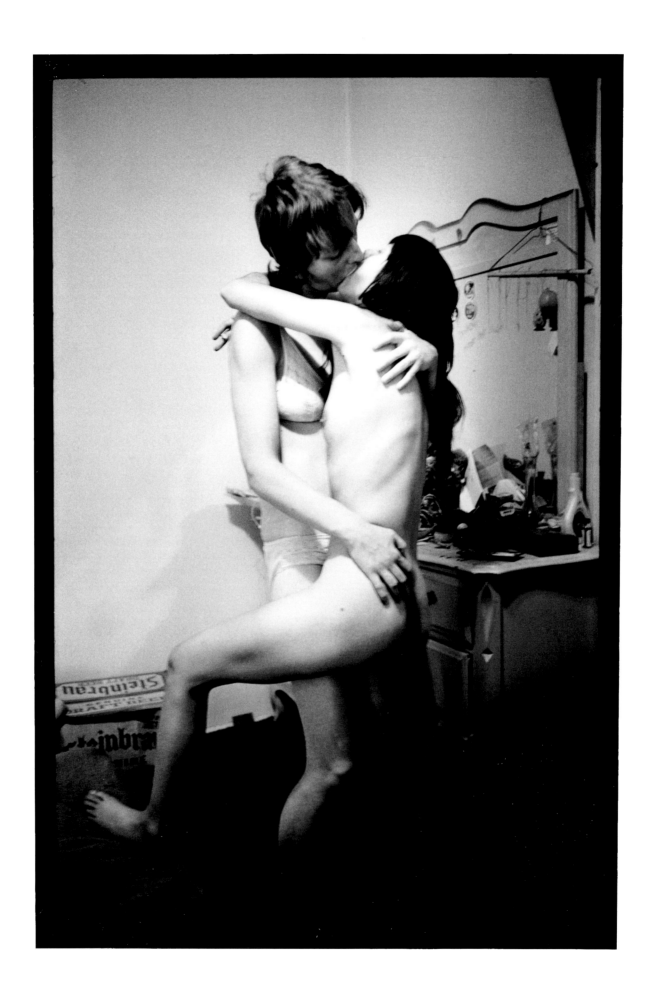

52: BOBBIE AND LINDA, VENICE, 1970

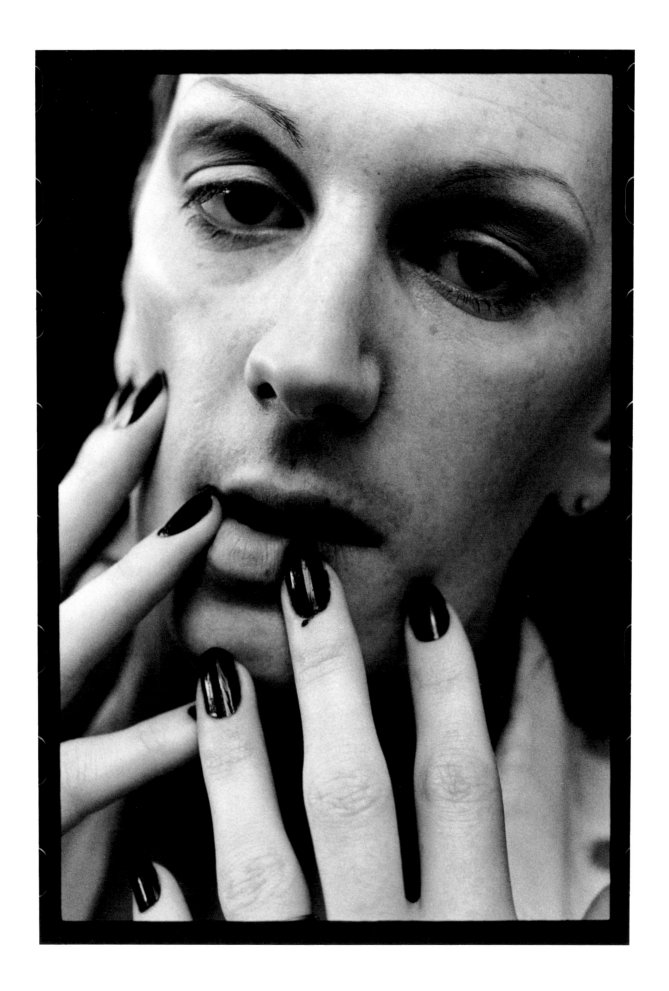

53: BRANDY, LOS ANGELES, 1970

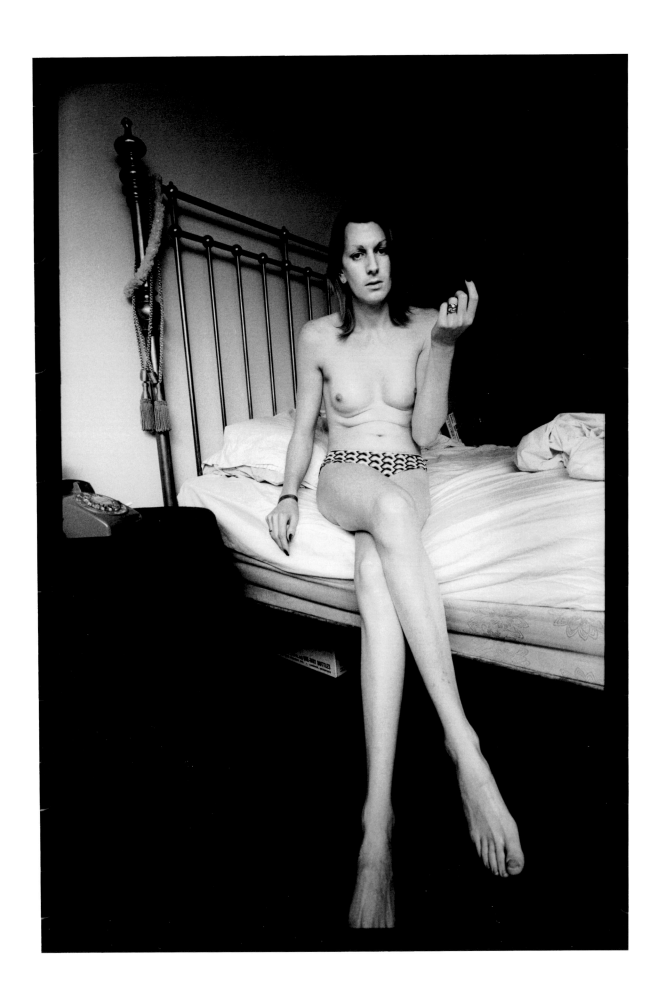

54: BRANDY, LOS ANGELES, 1970

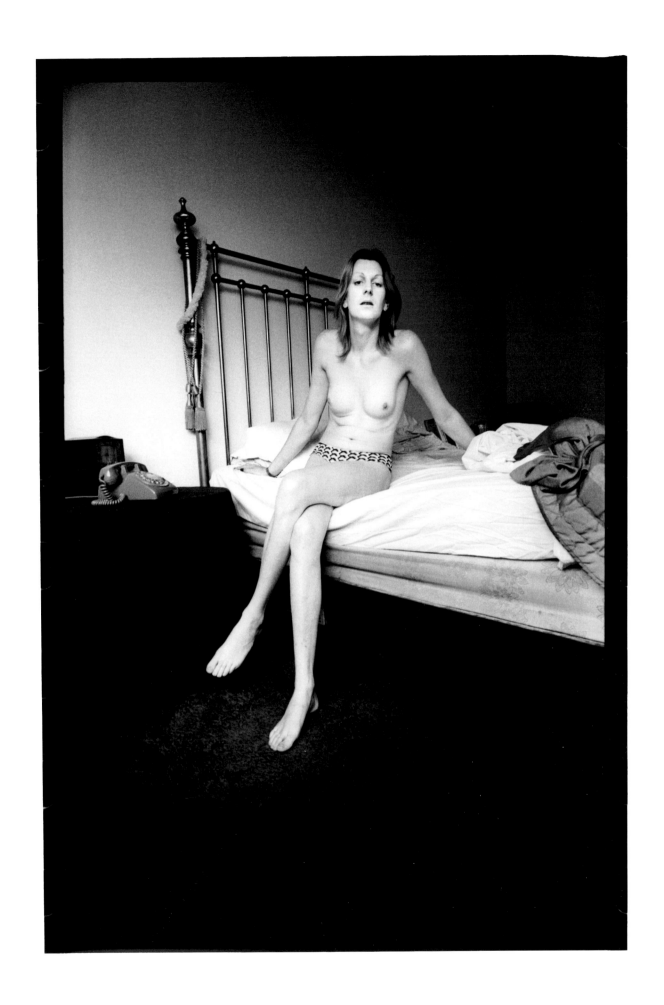

55: BRANDY, LOS ANGELES, 1970

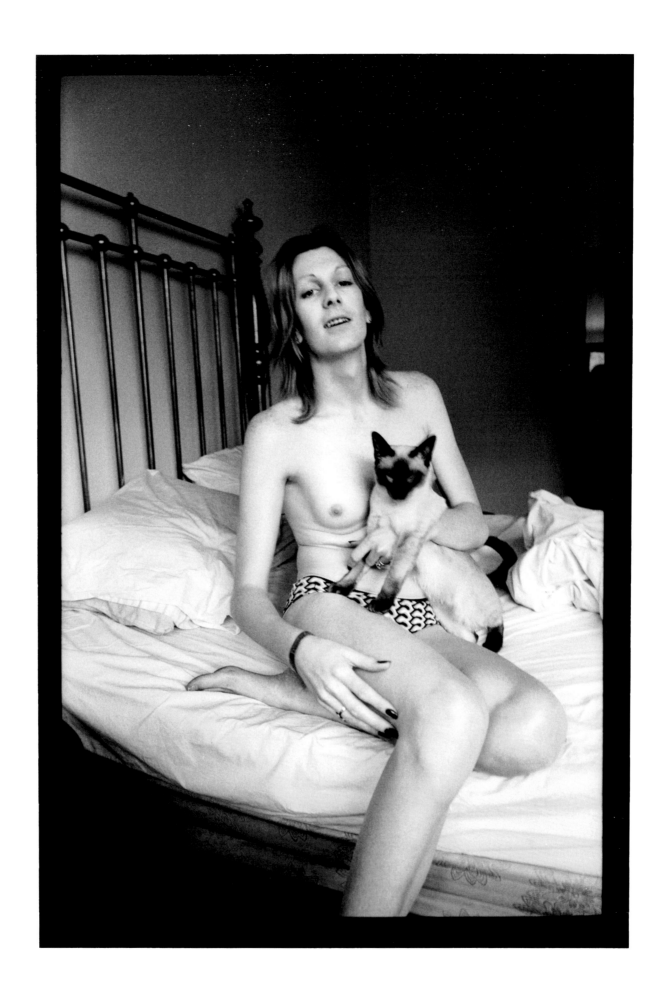

56: BRANDY WITH CAT, LOS ANGELES, 1970

57: KELLY, SILVERLAKE, 1972

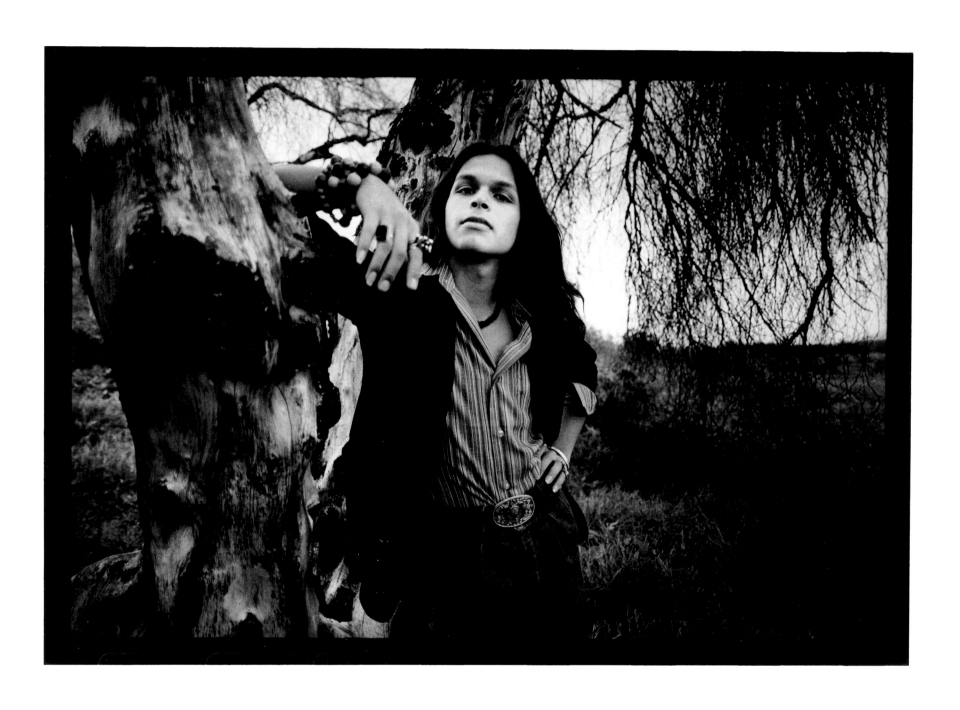

THEATER, SAN FRANCISCO

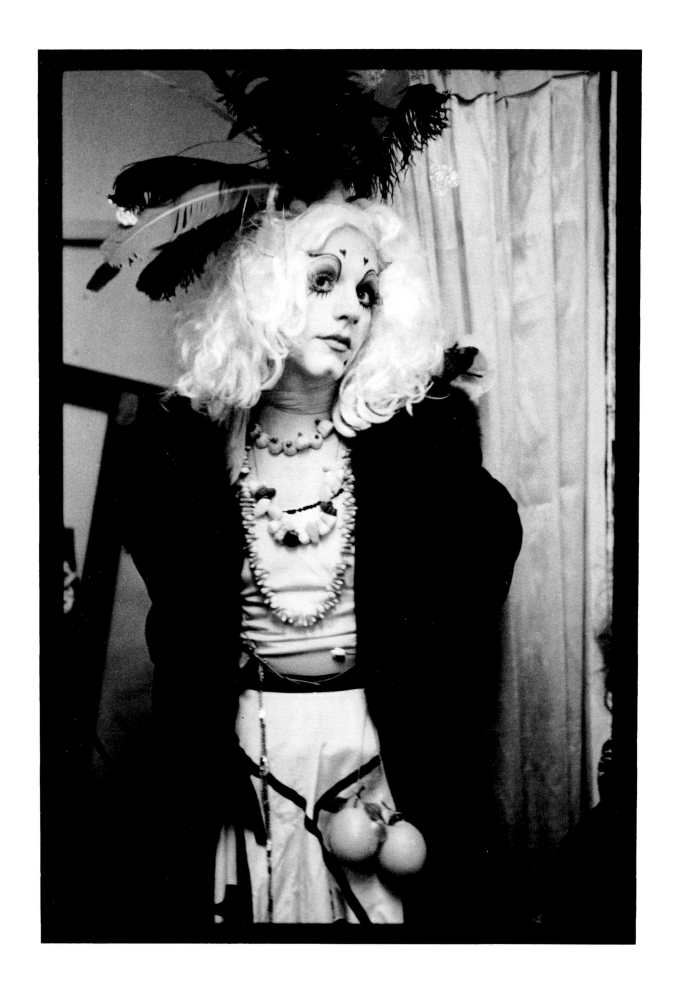

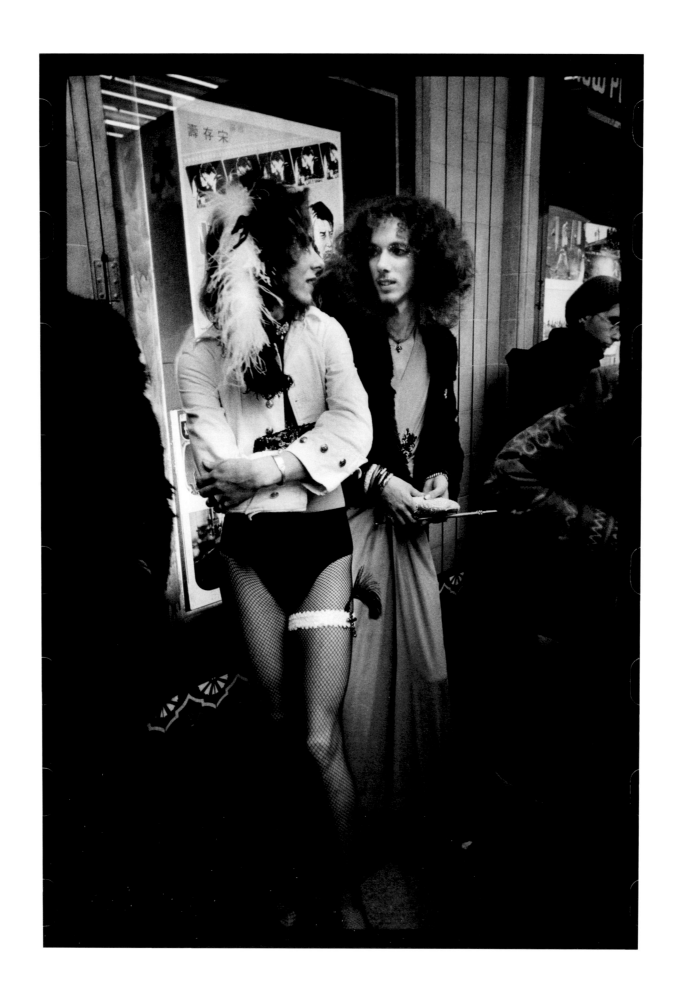

60: COUPLE, THE PALACE THEATER, SAN FRANCISCO, 1972

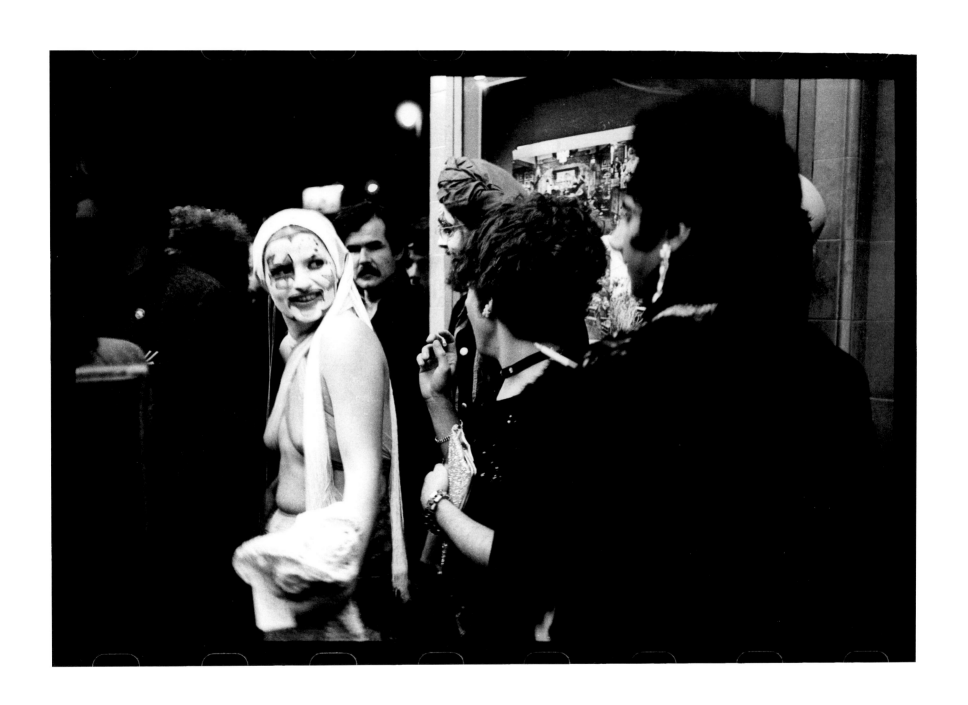

61: IN FRONT OF THE PALACE THEATER, SAN FRANCISCO, 1972

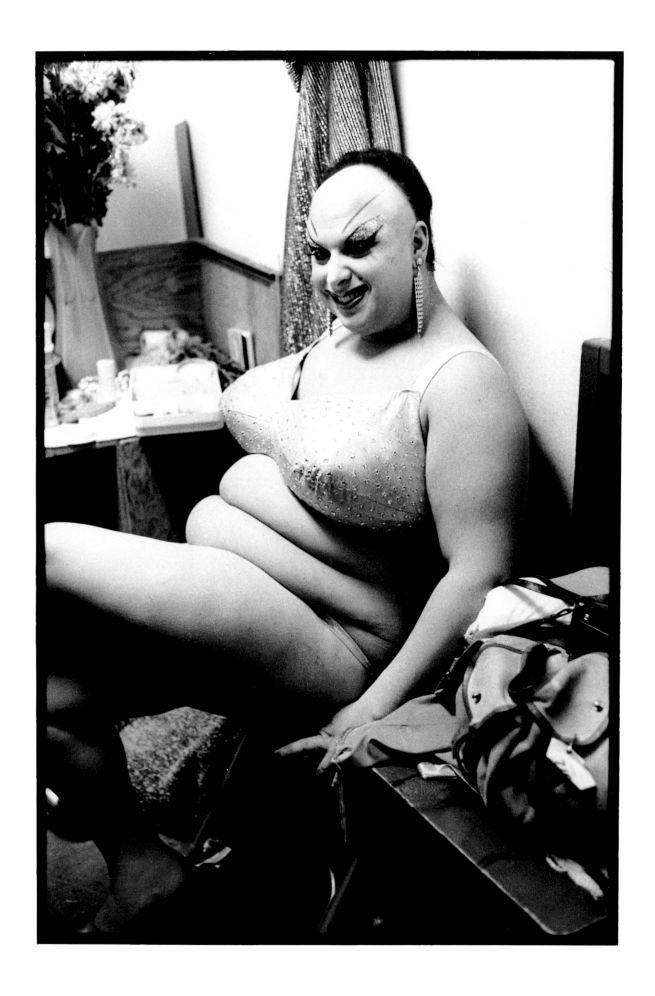

62: DIVINE, THE PALACE THEATER, SAN FRANCISCO, 1972

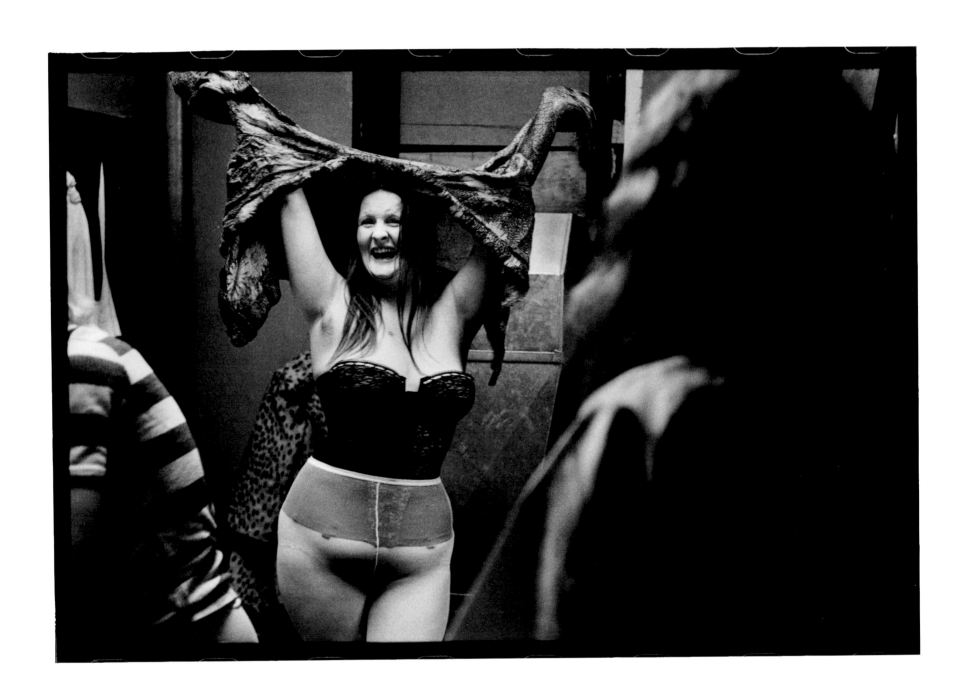

63: BACKSTAGE, THE PALACE THEATER, SAN FRANCISCO, 1972

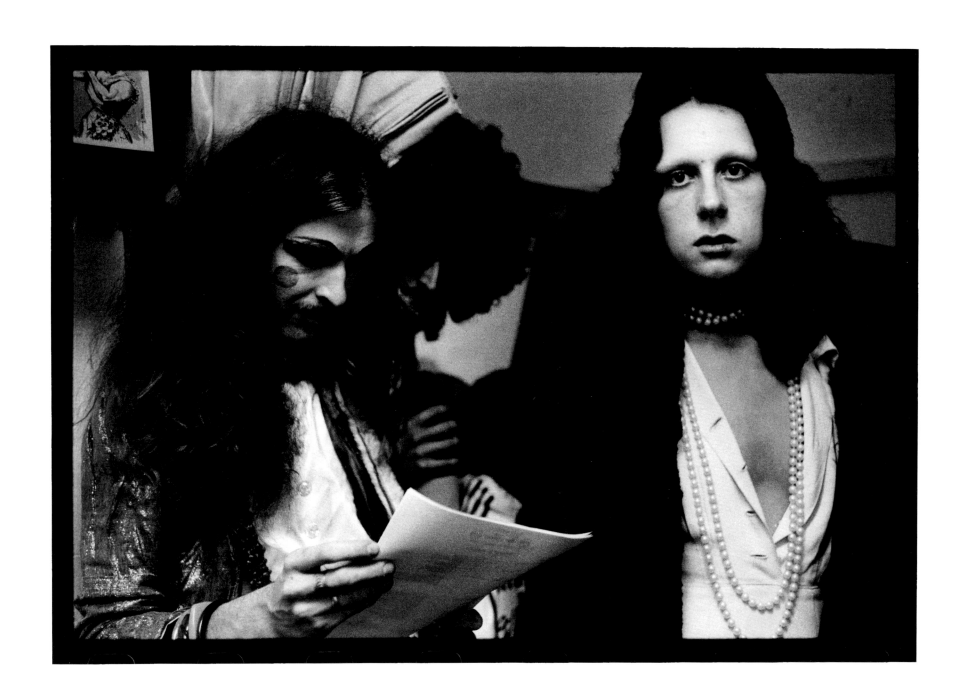

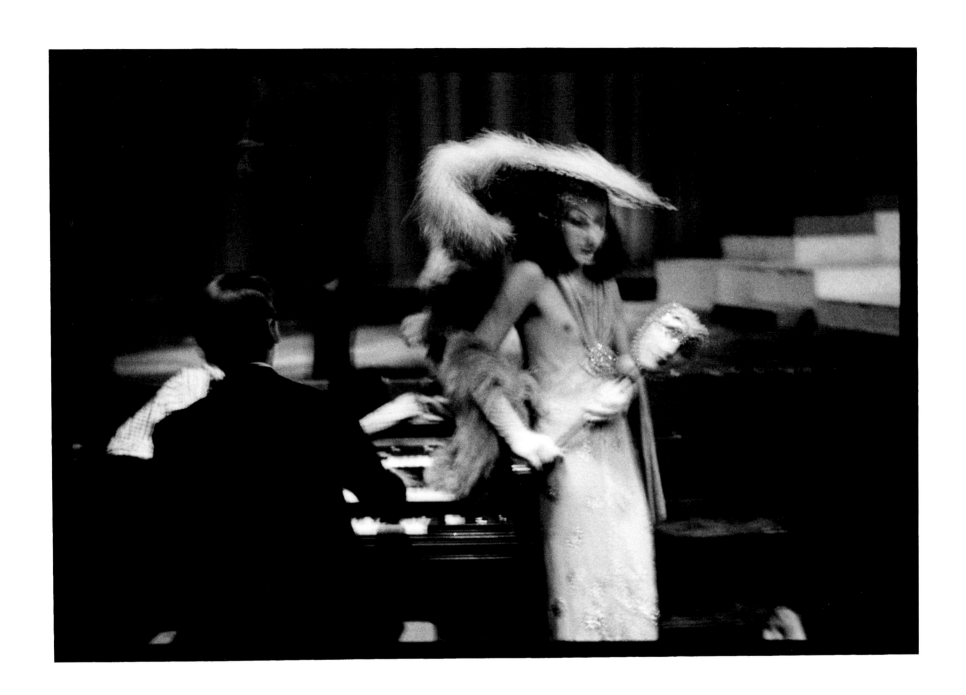

JIM AGUILAR

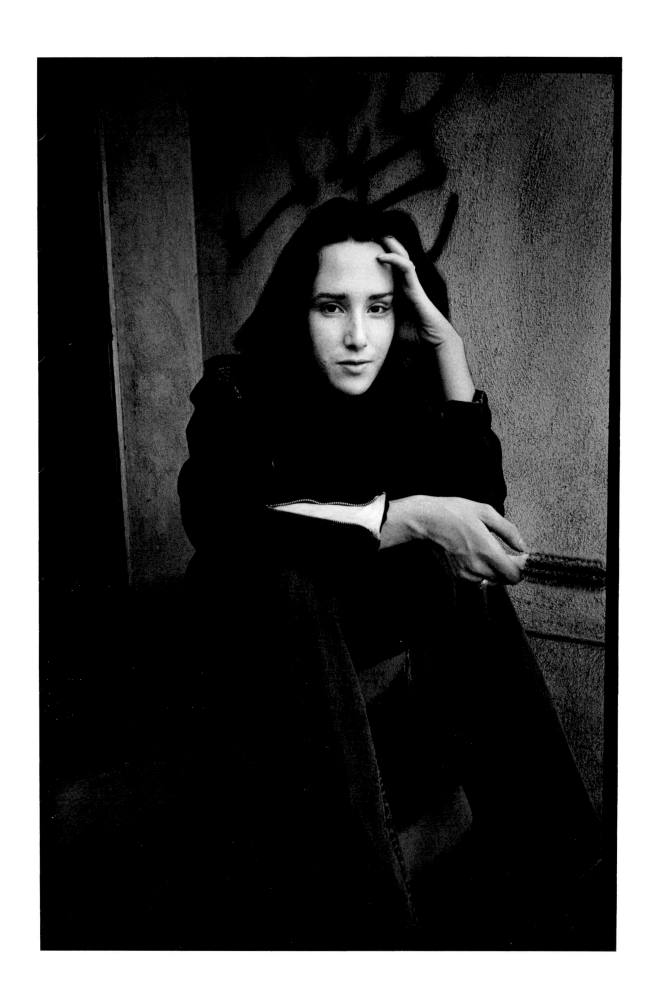

66: JIM, EAST LOS ANGELES, 1972

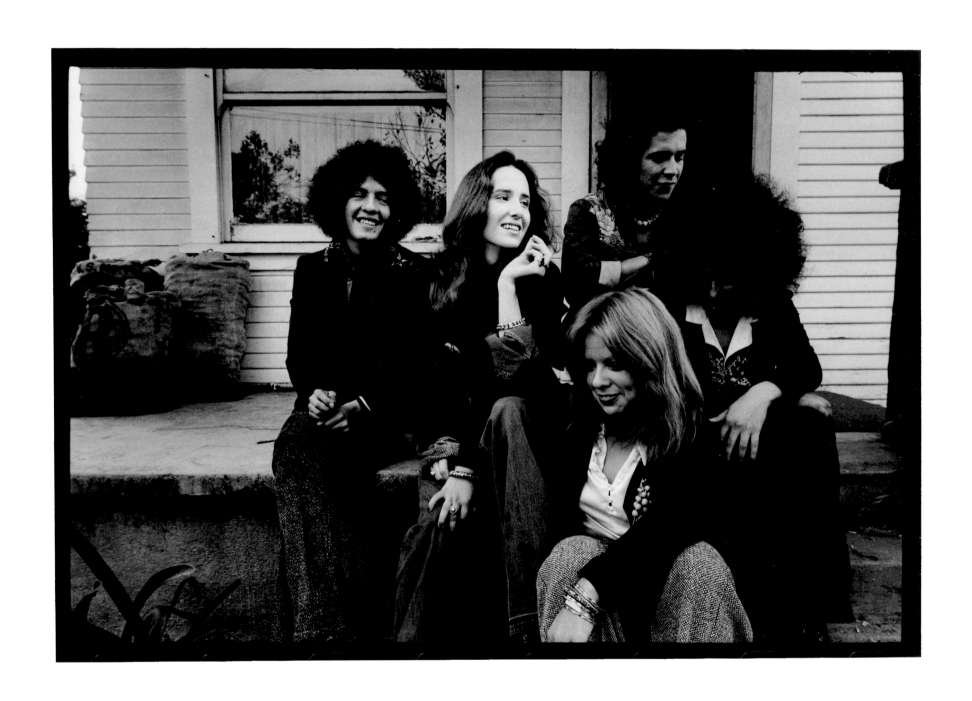

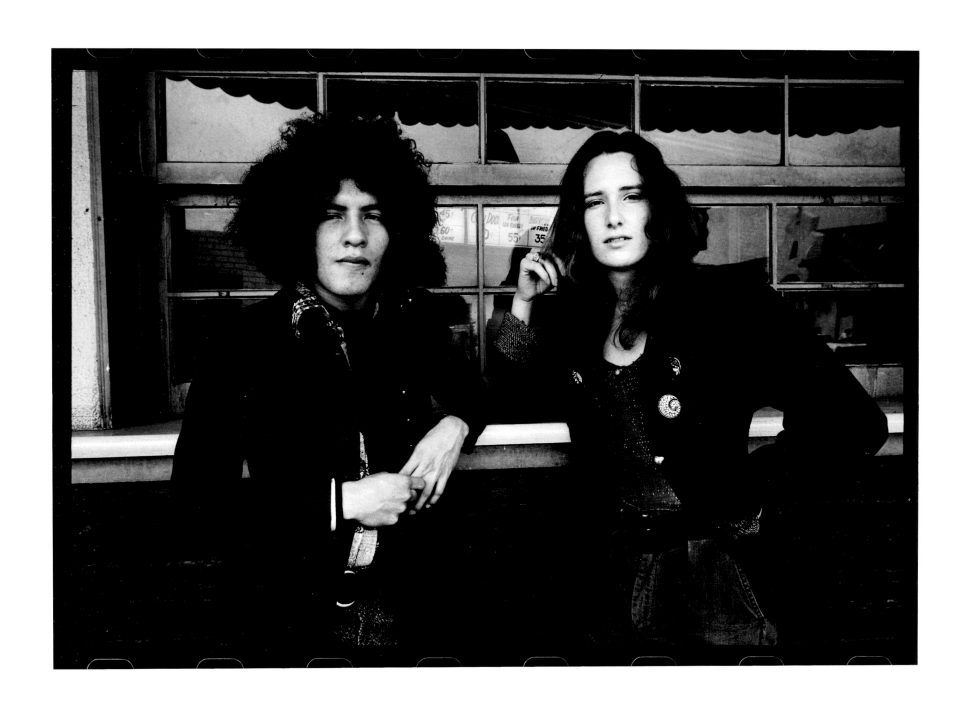

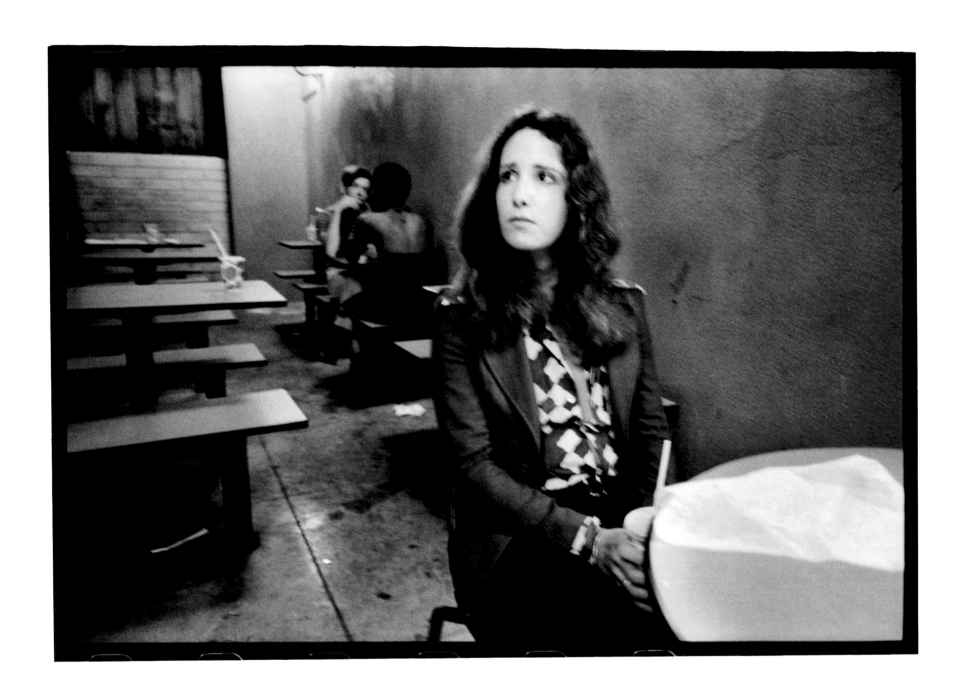

69: JIM WITH SODA, HOLLYWOOD, 1970

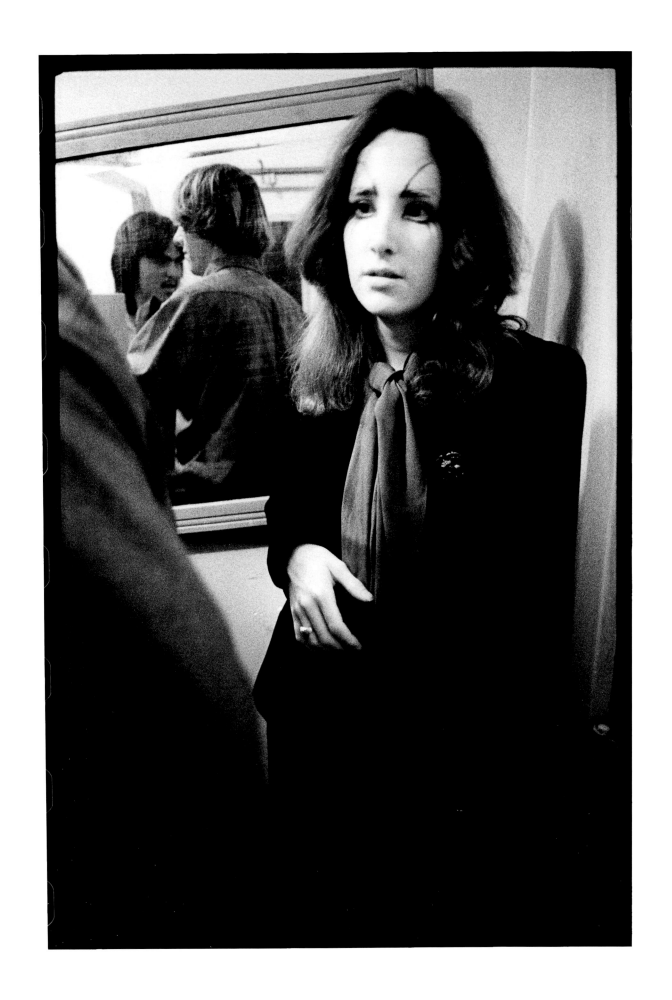

70: JIM, RESTROOM AT TROUPER'S HALL, HOLLYWOOD, 1970

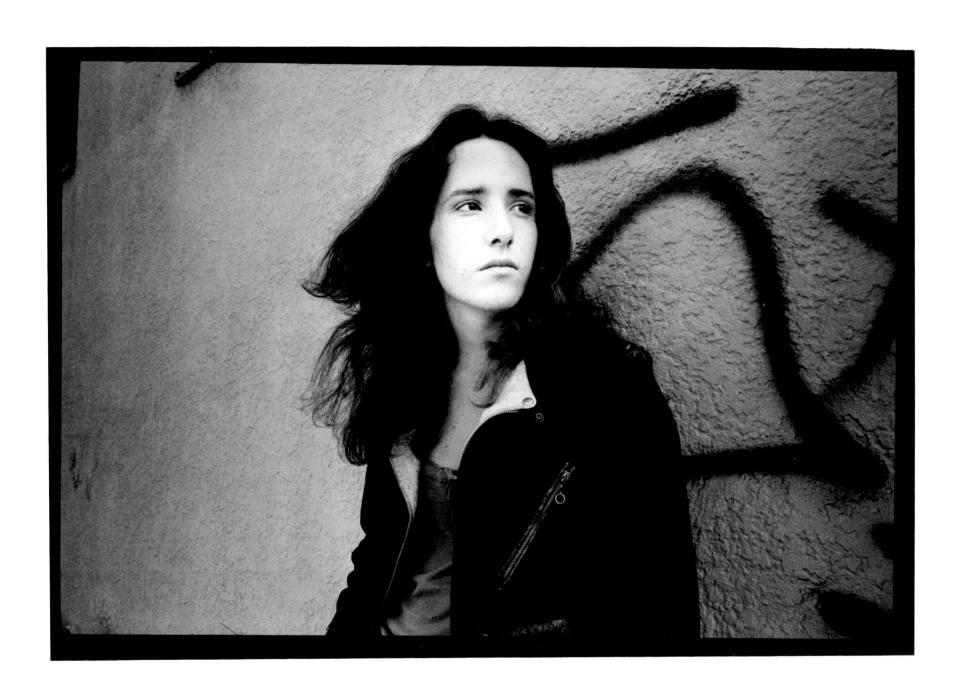

CATALOGUE OF THE EXHIBITION

This checklist documents the exhibition as presented at the de Young and reflects the most complete information available at the time of publication.

All photographs are vintage prints made by the artist and are part of the collection of the Fine Arts Museums of San Francisco.

TROUPER'S HALL

PLATE 1
YOUNG MAN, TROUPER'S HALL,
HOLLYWOOD, 1969
Gelatin silver print
14 × 11 in. (35.6 × 27.9 cm)
Gift of Mary and Dan Solomon
2011.66.10

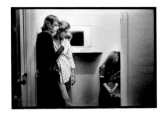

PLATE 2
RESTROOM, TROUPER'S HALL,
HOLLYWOOD, 1970
Gelatin silver print
11 × 14 in. (27.9 × 35.6 cm)
Anonymous gift in honor of Sheila Glassman
2012.70.38

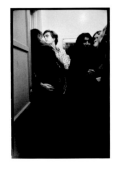

PLATE 3
RESTROOM, TROUPER'S HALL,
HOLLYWOOD, 1970
Gelatin silver print
14 × 11 in. (35.6 × 27.9 cm)
Anonymous gift in honor of Sheila Glassman
2012.70.33

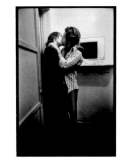

PLATE 4
COUPLE KISSING, RESTROOM, TROUPER'S
HALL, HOLLYWOOD, 1970
Gelatin silver print
14 × 11 in. (35.6 × 27.9 cm)
Anonymous gift in honor of Sheila Glassman
2012.70.29

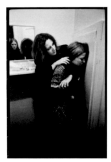

PLATE 5
JIM AND VALERIE, TROUPER'S HALL,
HOLLYWOOD, 1970
Gelatin silver print
14 × 11 in. (35.6 × 27.9 cm)
Anonymous gift in honor of Sheila Glassman
2012.70.30

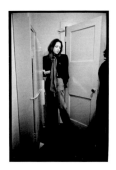

PLATE 6
JIM, RESTROOM AT TROUPER'S HALL,
HOLLYWOOD, 1970
Gelatin silver print
14 × 11 in. (35.6 × 27.9 cm)
Anonymous gift in honor of Sheila Glassman
2012.70.32

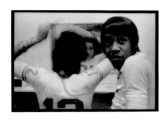

PLATE 7
RESTROOM, TROUPER'S HALL,
HOLLYWOOD, 1970
Gelatin silver print
11 × 14 in. (27.9 × 35.6 cm)
Anonymous gift in honor of Sheila Glassman
2012.70.36

THE CHRISTOPHER STREET
WEST PARADE

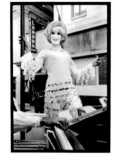

PLATE 8
MAY DOLL, GAY LIBERATION PARADE,
HOLLYWOOD, 1972
Gelatin silver print
14 × 11 in. (35.6 × 27.9 cm)
Anonymous gift
2011.58.34

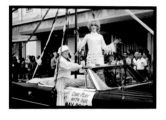

PLATE 9
MAY DOLL, GAY LIBERATION PARADE,
HOLLYWOOD, 1972
Gelatin silver print
11 × 14 in. (27.9 × 35.6 cm)
Anonymous gift
2011.58.33

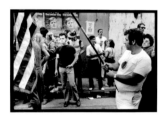

PLATE 10
GAY LIBERATION PARADE,
HOLLYWOOD, 1972
Gelatin silver print
11 × 14 in. (27.9 × 35.6 cm)
Anonymous gift
2011.58.35

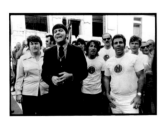

PLATE 11
REVEREND TROY PERRY AT GAY
LIBERATION PARADE, HOLLYWOOD, 1972
Gelatin silver print
8 × 10 in. (20.3 × 25.4 cm)
Anonymous gift
2011.58.37

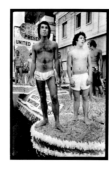

PLATE 12
THE SPREE FLOAT, GAY LIBERATION
PARADE, HOLLYWOOD, 1972
Gelatin silver print
14 × 11 in. (35.6 × 27.9 cm)
Anonymous gift
2011.58.38

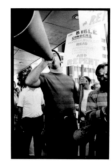

PLATE 13
"THE BIBLE CONDEMNS HOMOSEXUALITY,"
GAY LIBERATION PARADE,
HOLLYWOOD, 1972
Gelatin silver print
14 × 11 in. (35.6 × 27.9 cm)
Anonymous gift
2011.58.32

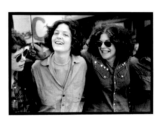

PLATE 14
GAY LIBERATION PARADE,
HOLLYWOOD, 1972
Gelatin silver print
11 × 14 in. (27.9 × 35.6 cm)
Anonymous gift
2011.58.23

HOLLYWOOD

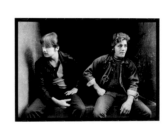

PLATE 15
HUSTLERS, SELMA AVENUE,
HOLLYWOOD, 1971
Gelatin silver print
11 × 14 in. (27.9 × 35.6 cm)
Gift of Mary and Dan Solomon
2011.66.8

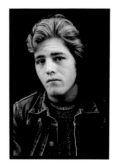

PLATE 16
HUSTLER, SELMA AVENUE,
HOLLYWOOD, 1971
Gelatin silver print
14 × 11 in. (35.6 × 27.9 cm)
Anonymous gift
2011.58.40

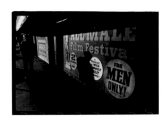

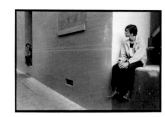

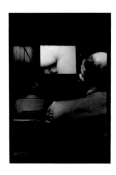

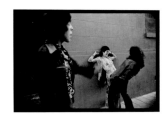

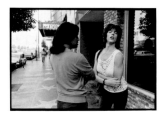

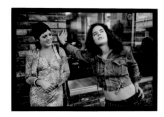

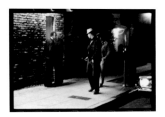

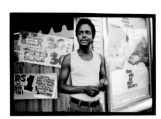

FEMALE IMPERSONATORS

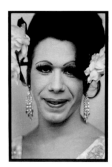

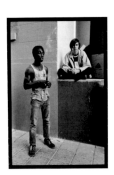

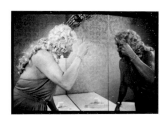

PLATE 27
DRAG QUEEN, LONG BEACH, 1971
Gelatin silver print
11×14 in. (27.9×35.6 cm)
Anonymous gift
2011.58.8

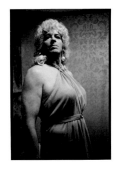

PLATE 28
DRAG QUEEN, LONG BEACH, 1971
Gelatin silver print
10×8 in. (25.4×20.3 cm)
Anonymous gift
2011.58.12

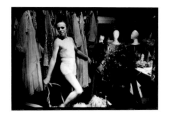

PLATE 29
DRESSING ROOM, "C'EST LA VIE" CLUB,
NORTH HOLLYWOOD, 1972
Gelatin silver print
11×14 in. (27.9×35.6 cm)
Anonymous gift
2011.58.4

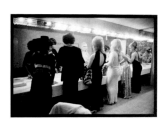

PLATE 30
DRAG QUEENS AT THE MIRROR,
LONG BEACH, 1971
Gelatin silver print
11×14 in. (27.9×35.6 cm)
Anonymous gift
2011.58.7

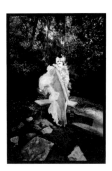

PLATE 31
CYCLONA, IN THE GARDEN,
LOS ANGELES, 1971
Gelatin silver print
14×11 in. (35.6×27.9 cm)
Anonymous gift in honor of Sheila Glassman
2012.70.1

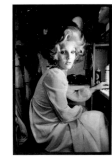

PLATE 32
MICHELLE, "C'EST LA VIE" CLUB,
NORTH HOLLYWOOD, 1972
Gelatin silver print
14×11 in. (35.6×27.9 cm)
Gift of Mary and Dan Solomon
2011.66.1

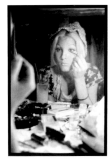

PLATE 33
MICHELLE, "C'EST LA VIE" CLUB,
NORTH HOLLYWOOD, 1972
Gelatin silver print
14×11 in. (35.6×27.9 cm)
Anonymous gift
2011.58.11

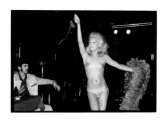

PLATE 34
MICHELLE DANCING, "C'EST LA VIE" CLUB,
NORTH HOLLYWOOD, 1972
Gelatin silver print
11×14 in. (27.9×35.6 cm)
Anonymous gift
2011.58.3

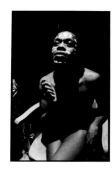

PLATE 35
PUTTING ON MAKE-UP, "C'EST LA VIE"
CLUB, NORTH HOLLYWOOD, 1972
Gelatin silver print
10×8 in. (25.4×20.3 cm)
Anonymous gift
2011.58.5

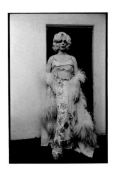

PLATE 36
JEAN HARLOW, DRAG QUEEN BALL,
LONG BEACH, 1971
Gelatin silver print
10 × 8 in. (25.4 × 20.3 cm)
Anonymous gift
2011.58.6

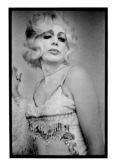

PLATE 37
JEAN HARLOW, DRAG QUEEN BALL,
LONG BEACH, 1971
Gelatin silver print
14 × 11 in. (35.6 × 27.9 cm)
Anonymous gift
2011.58.2

PORTRAITS

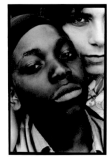

PLATE 38
COUPLE, LOS ANGELES, 1970
Gelatin silver print
10 × 8 in. (25.4 × 20.3 cm)
Anonymous gift
2011.58.20

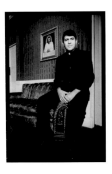

PLATE 39
THE REVEREND TROY PERRY, GAY
ACTIVIST, LOS ANGELES, 1973
Gelatin silver print
14 × 11 in. (35.6 × 27.9 cm)
Anonymous gift in honor of Sheila Glassman
2012.70.4

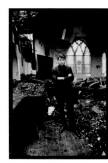

PLATE 40
THE REVEREND TROY PERRY, GAY
ACTIVIST, IN HIS BURNT DOWN CHURCH,
LOS ANGELES, 1973
Gelatin silver print
14 × 11 in. (35.6 × 27.9 cm)
Anonymous gift in honor of Sheila Glassman
2012.70.3

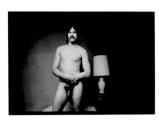

PLATE 41
DAN, HUSTLER, BURBANK, 1970
Gelatin silver print
11 × 14 in. (27.9 × 35.6 cm)
Anonymous gift in honor of Sheila Glassman
2012.70.16

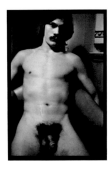

PLATE 42
DAN, HUSTLER, BURBANK, 1970
Gelatin silver print
14 × 11 in. (35.6 × 27.9 cm)
Anonymous gift in honor of Sheila Glassman
2012.70.17

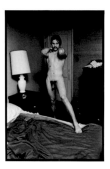

PLATE 43
DAN, HUSTLER, BURBANK, 1970
Gelatin silver print
10 × 8 in. (25.4 × 20.3 cm)
Gift of Mary and Dan Solomon
2011.66.14

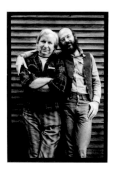

PLATE 44
DON KILHEFNER AND MORRIS KIGHT
AT THE GAY COMMUNITY SERVICES
CENTER, LOS ANGELES, 1972
Gelatin silver print
14 × 11 in. (35.6 × 27.9 cm)
Gift of Mary and Dan Solomon
2011.66.4

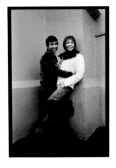

PLATE 45
COUPLE IN FRONT OF CHURCH,
LOS ANGELES, 1970
Gelatin silver print
14 × 11 in. (35.6 × 27.9 cm)
Anonymous gift
2011.58.21

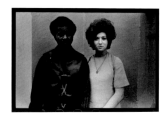

PLATE 46
COUPLE IN FRONT OF CHURCH,
LOS ANGELES, 1970
Gelatin silver print
11 × 14 in. (27.9 × 35.6 cm)
Anonymous gift
2011.58.19

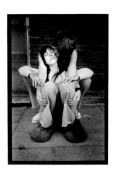

PLATE 47
BOBBIE AND LINDA, VENICE, 1970
Gelatin silver print
14 × 11 in. (35.6 × 27.9 cm)
Gift of Mary and Dan Solomon
2011.66.3

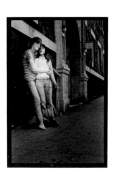

PLATE 48
BOBBIE AND LINDA IN FRONT OF THEIR
APARTMENT, VENICE, 1970
Gelatin silver print
14 × 11 in. (35.6 × 27.9 cm)
Anonymous gift
2011.58.18

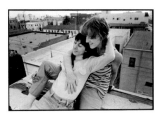

PLATE 49
BOBBIE AND LINDA ON ROOFTOP,
VENICE, 1970
Gelatin silver print
11 × 14 in. (27.9 × 35.6 cm)
Anonymous gift
2011.58.22

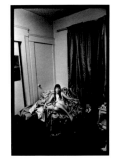

PLATE 50
BOBBIE, VENICE, 1970
Gelatin silver print
14 × 11 in. (35.6 × 27.9 cm)
Anonymous gift in honor of Sheila Glassman
2012.70.11

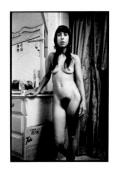

PLATE 51
BOBBIE, VENICE, 1970
Gelatin silver print
14 × 11 in. (35.6 × 27.9 cm)
Anonymous gift in honor of Sheila Glassman
2012.70.10

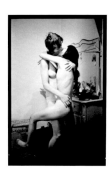

PLATE 52
BOBBIE AND LINDA, VENICE, 1970
Gelatin silver print
14 × 11 in. (35.6 × 27.9 cm)
Anonymous gift
2011.58.17

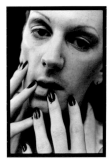

PLATE 53
BRANDY, LOS ANGELES, 1970
Gelatin silver print
14 × 11 in. (35.6 × 27.9 cm)
Anonymous gift in honor of Sheila Glassman
2012.70.6

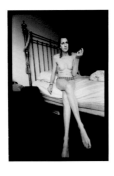

PLATE 54
BRANDY, LOS ANGELES, 1970
Gelatin silver print
14×11 in. (35.6×27.9 cm)
Anonymous gift in honor of Sheila Glassman
2012.70.9

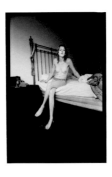

PLATE 55
BRANDY, LOS ANGELES, 1970
Gelatin silver print
14×11 in. (35.6×27.9 cm)
Anonymous gift in honor of Sheila Glassman
2012.70.13

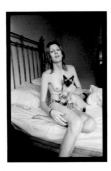

PLATE 56
BRANDY WITH CAT, LOS ANGELES, 1970
Gelatin silver print
14×11 in. (35.6×27.9 cm)
Anonymous gift in honor of Sheila Glassman
2012.70.8

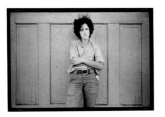

PLATE 57
KELLY, SILVERLAKE, 1972
Gelatin silver print
11×14 in. (27.9×35.6 cm)
Gift of Mary and Dan Solomon
2011.66.12

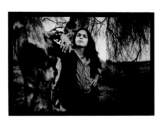

PLATE 58
ROBERT, EAST LOS ANGELES, 1972
Gelatin silver print
11×14 in. (27.9×35.6 cm)
Anonymous gift in honor of Sheila Glassman
2012.70.7

THEATER, SAN FRANCISCO

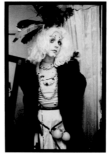

PLATE 59
**PRISTINE CONDITION, THE PALACE
THEATER, SAN FRANCISCO,** 1972
Gelatin silver print
14×11 in. (35.6×27.9 cm)
Anonymous gift in honor of Sheila Glassman
2012.70.25

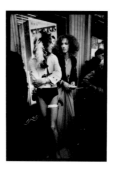

PLATE 60
**COUPLE, THE PALACE THEATER,
SAN FRANCISCO,** 1972
Gelatin silver print
14×11 in. (35.6×27.9 cm)
Anonymous gift
2011.58.1

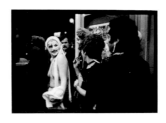

PLATE 61
**IN FRONT OF THE PALACE THEATER,
SAN FRANCISCO,** 1972
Gelatin silver print
11×14 in. (27.9×35.6 cm)
Anonymous gift in honor of Sheila Glassman
2012.70.27

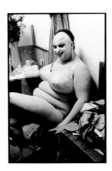

PLATE 62
**DIVINE, THE PALACE THEATER,
SAN FRANCISCO,** 1972
Gelatin silver print
14×11 in. (35.6×27.9 cm)
Anonymous gift in honor of Sheila Glassman
2012.70.24

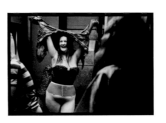

PLATE 63
**BACKSTAGE, THE PALACE THEATER,
SAN FRANCISCO,** 1972
Gelatin silver print
11×14 in. (27.9×35.6 cm)
Anonymous gift in honor of Sheila Glassman
2012.70.23

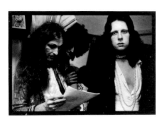

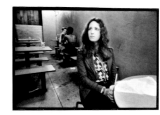

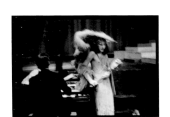

JIM AGUILAR
...

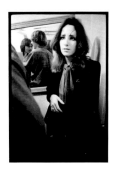

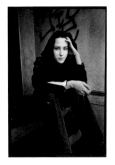

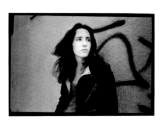

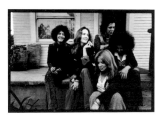

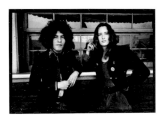

AFTERWORD

ANTHONY FRIEDKIN

THIS BOOK is dedicated to the many extraordinary individuals who allowed me into their lives and warmly welcomed me, with my camera in hand, to witness and document their lifestyles.

I was a young photographer following my instincts, and creating *The Gay Essay* has turned out to be one of the most important projects of my life. What was revealed to me through making this work is the human need to experience intimacy and love, along with a deep desire to connect with one another in passionate, physical ways. These are feelings that all people on earth share. They are universal truths. Everyone's sexuality is unique, and it is something to celebrate and embrace.

The mistreatment of people in the gay community was one of the initial reasons that I wanted to photograph *The Gay Essay*. It seemed tragically unfair and deplorable that people were hostile and threatening to others based on their sexual identity. Using my photographs as a means of artistic expression, I wanted to explore this issue in a very personal way.

Morris Kight and Don Kilhefner, who were then the directors of the Gay Community Services Center in Los Angeles, were enormously helpful to me. They ushered me into their world and trusted me. The bulk of these photographs could not have been created without their support.

I always hoped that this work one day would be published as a book. I am especially grateful to Julian Cox, Founding Curator of Photography and Chief Administrative Curator at the Fine Arts Museums of San Francisco, along with his colleagues, for their dedicated efforts to make this hope a reality. I also want to thank Mary and Dan Solomon, who were instrumental in initiating this exhibition and publication.

Anthony Friedkin, contact proof sheet for *The Gay Essay*, ca. 1970–1972
Gelatin silver print, 10¾ × 11¼ in. (27.6 × 28.6 cm)
Collection of the artist

SELECTED BIBLIOGRAPHY

Abbott, Brett. *Engaged Observers: Documentary Photography since the Sixties*. Los Angeles: J. Paul Getty Museum, 2010.

Ackerley, J. R. *My Father and Myself*. New York: Coward-McCann, Inc., 1968.

Allyn, David. *Make Love, Not War. The Sexual Revolution: An Unfettered History*. Boston and New York: Little, Brown and Company, 2001.

American Law Institute. *Model Penal Code—Proposed Final Draft Number 1*. Philadelphia: American Law Institute, 1961.

Baldwin, James. *Giovanni's Room*. New York: Dial Press, 1956.

Boot, Chris, ed. *Magnum Stories*. London: Phaidon Press, 2004.

Bronski, Michael. *A Queer History of the United States*. Boston: Beacon Press, 2011.

Brown, Norman O. *Love's Body*. New York: Random House, 1966.

Capa, Cornell, ed. *The Concerned Photographer*. New York: Grossman, 1968.

Carter, David. *Stonewall: The Riots That Sparked the Gay Revolution*. New York: St. Martin's Griffin, 2004.

Cartier-Bresson, Henri. *The Decisive Moment*. New York: Simon & Schuster, 1952.

Churchill, Wainwright. *Homosexual Behavior among Males*. New York: Hawthorn Books, 1967.

Collins, Kathleen, ed. *Shadow and Substance: Essays on the History of Photography*. Bloomfield Hills, MI: Amorphous Institute Press, 1990.

Cory, Donald W. *The Homosexual in America*. New York: Greenberg, 1951.

———. *Homosexuality: A Cross Cultural Approach*. New York: Julian Press, 1956.

Cox, Julian. *Timekeeper: Anthony Friedkin*. Los Angeles: Enton Publishing Co., 2003.

Davis, Keith F. *An American Century of Photography: From Dry-Plate to Digital*. Kansas City, MO: Hallmark Cards, Inc., 1999.

De Beauvoir, Simone. *The Second Sex*. New York: Alfred A. Knopf, Inc., 1952.

De Becker, Raymond. *The Other Face of Love*. New York: Grove Press, 1969.

Duberman, Martin. *About Time: Exploring the Gay Past*. New York: Meridian Books, 1991.

———. *Stonewall*. New York: Plume, 1993.

Engels, Frederick. *The Origin of the Family, Private Property, and the State*. New York: International Publishers, 1942.

Faderman, Lillian, and Stuart Timmons. *Gay L.A.: A History of Sexual Outlaws, Power and Politics, and Lipstick Lesbians*. Berkeley: University of California Press, 2006.

Featherstone, David, ed. *Observations: Essays on Documentary Photography*. Carmel, CA: Friends of Photography, 1984.

Ford, Clellan S., and Frank A. Beach. *Patterns of Sexual Behavior*. New York: Harper & Row, 1951.

Fulton, Marianne. *Eyes of Time: Photojournalism in America*. New York: New York Graphic Society, 1988.

Gallo, Marcia M. *Different Daughters: A History of the Daughters of Bilitis and the Rise of the Lesbian Rights Movement*. New York: Carroll & Graf, 2006.

Garde, Noel I. *Jonathan to Gide: The Homosexual in History*. New York: Vantage Press, 1964.

Gerassi, John. *The Boys of Boise: Furor, Vice, and Folly in an American City*. New York: Macmillan, 1966.

Hirshman, Linda. *Victory: The Triumphant Gay Revolution*. New York: HarperCollins, 2012.

Hoffman, Martin. *The Gay World*. New York: Basic Books, 1968.

Humphreys, Laud. *Tearoom Trade: Impersonal Sex in Public Places*. Chicago: Aldine, 1970.

Kinsey, Alfred, W. B. Pomeroy, and C. E. Martin. *Sexual Behavior in the Human Male*. Philadelphia: W. B. Saunders Co., 1948.

Light, Ken. *Witness in Our Time: Working Lives of Documentary Photographers*. Washington, DC: Smithsonian Institution Press, 2000.

Marcuse, Herbert. *Eros and Civilization*. Boston: Beacon Press, 1966.

Mecca, Tommi Avicolli, ed. *Smash the Church, Smash the State! The Early Years of Gay Liberation*. San Francisco: City Lights Books, 2009.

Millett, Kate. *Sexual Politics*. Garden City, NY: Doubleday & Co., Inc., 1970.

Parr, Martin, and Gerry Badger. *The Photobook: A History*, vol. 1. London: Phaidon Press, 2004.

———. *The Photobook: A History*, vol. 2. London: Phaidon Press, 2006.

Solomon-Godeau, Abigail. *Photography at the Dock: Essays on Photographic History, Institutions, and Practices*. Minneapolis: University of Minnesota Press, 1991.

Talbot, David. *Season of the Witch: Enchantment, Terror, and Deliverance in the City of Love*. New York: Free Press, 2012.

Tobin, Kay, and Randy Wicker. *The Gay Crusaders*. New York: Paperback Library, 1972.

Westerbeck, Colin, and Joel Meyerowitz. *Bystander: A History of Street Photography*. Boston: Little, Brown and Company, 1994.

White, C. Todd. *Pre-Gay L.A.: A Social History of the Movement for Homosexual Rights*. Urbana and Chicago: University of Illinois Press, 2009.

Willumson, Glenn G. *W. Eugene Smith and the Photographic Essay*. Cambridge and New York: Cambridge University Press, 1992.

ACKNOWLEDGMENTS

This exhibition and publication were precipitated by an act of generosity from Mary and Dan Solomon. In the fall of 2010, they chose the Fine Arts Museums of San Francisco as the repository for the master set of vintage prints from *The Gay Essay*, Anthony Friedkin's first extended photo-essay, begun when he was only a few years out of high school. I thank them for their commitment to this work and for entrusting our Museums with the responsibility of bringing *The Gay Essay* to a wider public through this exhibition and its accompanying catalogue. Their conviction was shared by donors Nancy Ascher and John Roberts, who also contributed greatly to the formation of our Friedkin holdings. I am deeply grateful to them all.

At the Fine Arts Museums of San Francisco, I thank Colin B. Bailey, Director of Museums, for his spirited support of this project since his arrival at the institution in June 2013. Thanks are also extended to Richard Benefield, Deputy Director; Michele Gutierrez-Canepa, Chief Financial Officer and Foundation Fiscal Officer; Deanna Griffin, Senior Administrator, Director's Office; and Laura Florio, Grants Manager. Sincere appreciation is given to the Museums' exhibitions team, Krista Brugnara, Director of Exhibitions; Therese Chen, Collections Manager and Director of Registration; Bill Huggins, Lighting Designer; Craig Harris, Manager of Installation and Preparation; and Daniel Meza, Graphic Design Director. Additional gratitude is extended to conservators Debra Evans and Victoria Binder and to Don Larsen for the care and presentation of the prints. In the Education department, I thank Sheila Pressley, Renee Baldocchi, and Gregory Stock, and in Marketing and Communications, I thank Sarah Bailey Hogarty and Clara Hatcher.

This publication was overseen by Leslie Dutcher, Director of Publications, who supported it from start to finish with enthusiasm. Thanks are also extended to Laura Harger, Editor; Sue Grinols, Director of Imaging Services; and Jorge Bachman and Randy Dodson, Museums photographers, who produced the high-quality reproductions in this volume. I also thank Patricia Fidler and her colleagues at Yale University Press for their esteemed partnership; Bob Aufuldish, for his seamless book design; Sue Medlicott, Nerissa Vales, and Michelle Woo of the Production Department for their help with the myriad production details; and Massimo Tonolli and his colleagues at Trifolio for their beautiful printing of this book. I am further grateful to the Andrew W. Mellon Foundation Endowment for Publications, which has made this catalogue possible.

For their rich contributions to this publication, I thank Nayland Blake and Eileen Myles. Both entered fully into the spirit of the project and produced writing that responds vibrantly to the photographs and significantly enriches this volume. Among my curatorial colleagues, I particularly acknowledge Apsara DiQuinzio, Curator of Modern and Contemporary Art and Phyllis C. Wattis MATRIX Curator at the University of California, Berkeley Art Museum, for her insights during the planning phase for this publication; and Brian Wallis, Chief Curator, International Center of Photography, New York, who supported the project from the outset and provided valuable guidance that has added greatly to the exhibition and catalogue.

I am also pleased to thank the following individuals who invigorated my research in various ways: Marjorie Bryer, Managing Archivist, San Francisco Gay, Lesbian, Bisexual, Transgender Historical Society; Tim Wilson, Librarian and Processing Archivist, San Francisco Public Library and Gay & Lesbian Center; Christina Moretta, Photo Curator, San Francisco History Center at the San Francisco Public Library; Joe Struble, George Eastman House International Museum of Photography and Film, Rochester, New York; Karen Hellman, J. Paul Getty Museum, Los Angeles; Eve Schillo, Los Angeles County Museum of Art; and Barbara Rominski, Head Librarian, San Francisco Museum of Modern Art Research Library and Archives. Other colleagues who kindly provided support and information are Tim Wride, Robert Flynt, Taj Forer, Andrea Huber, Kevin Moore, Richard Misrach, Daniel Nicoletta, Hal Fischer, and Daniell Cornell.

My greatest debt, of course, is to Anthony Friedkin, whose fervor for the subject and dedication to the art of photography I am proud to share with our audiences. I am grateful to have had the privilege of collaborating with him so closely on the presentation of this notable early chapter of his life's work.

Julian Cox
Founding Curator of Photography and Chief Administrative Curator
Fine Arts Museums of San Francisco

CONTRIBUTORS

ANTHONY FRIEDKIN's photographs are included in the permanent collections of the Fine Arts Museums of San Francisco; the International Center of Photography, New York; the J. Paul Getty Museum, Los Angeles; the Museum of Modern Art, New York; the Los Angeles County Museum of Art; and the George Eastman House International Museum of Photography and Film, Rochester, New York. He received a National Endowment for the Arts grant in 1977. He has taught photography at the University of California, Los Angeles, and the California Institute of the Arts and has lectured at the J. Paul Getty Museum and other educational institutions. His work has appeared in *Rolling Stone*, *Newsweek*, *French Zoom*, the *Los Angeles Times*, *Malibu* magazine, and numerous books, including *Los Angeles: Portrait of a City*, Taschen's comprehensive 2009 volume on the city, and the Huntington Library's *This Side of Paradise: Body and Landscape in Los Angeles Photographs* (2008). His monograph, *Timekeeper*, was self-published in 2003.

JULIAN COX is the Fine Arts Museums of San Francisco's Founding Curator of Photography and Chief Administrative Curator. His prior curatorial appointments include positions at the National Museum of Photography, Film and Television (now the National Media Museum), Bradford, England; the J. Paul Getty Museum, Los Angeles; and the High Museum of Art, Atlanta. He coauthored, with Colin Ford, the critically acclaimed publication *Julia Margaret Cameron: The Complete Photographs* (2003), the first catalogue raisonné of Cameron's work. Other notable publications include *Road to Freedom: Photographs of the Civil Rights Movement, 1956–1968* (2008); *The Portrait Unbound: Photographs by Robert Weingarten* (2010); *Real to Real: Photographs from the Traina Collection* (2012); and *The Errand of the Eye: Photographs by Rose Mandel* (2013).

NAYLAND BLAKE is an artist, writer, and educator. His writings have appeared in *Interview Magazine*, *Artforum*, *Out*, and *Outlook*. He is the author of numerous catalogue essays and was the cocurator and coeditor, with Lawrence Rinder, of the groundbreaking exhibition and catalogue *In a Different Light: Visual Culture, Sexual Identity, Queer Practice* (1995). He is the chair of the ICP-Bard Program in Advanced Photographic Studies at the International Center of Photography, New York.

EILEEN MYLES is a New York–based poet and writer. Her recent books include *Snowflake/different streets*, *Inferno*, and *The Importance of Being Iceland* (2009), which received a Creative Capital | Warhol Foundation Writers Grant. Her writing has appeared in *Art in America*, *Artforum*, *Parkett*, *Harper's*, *AnOther Magazine*, *The Believer*, and *The Nation*. She received the Shelley Memorial Award from the Poetry Society of America in 2010 and was a Guggenheim Fellow in 2012.

This catalogue is published by the Fine Arts Museums of San Francisco in association with Yale University Press on the occasion of the exhibition *Anthony Friedkin: The Gay Essay:*

de Young, San Francisco
June 14, 2014–January 11, 2015

This catalogue is published with the assistance of the Andrew W. Mellon Foundation Endowment for Publications.

Photo credits
fig. 1: Courtesy of Bill Eppridge and © 1964 The Picture Collection Inc. Reprinted with permission. All rights reserved.
figs. 19–21: Courtesy of the International Center of Photography.

Details
Front cover: detail of pl. 37
p. 2: Anthony Friedkin, *Couple, Los Angeles* (detail), 1970. Gelatin silver print, 10 × 8 in. (25.4 × 20.3 cm). Anonymous gift, Fine Arts Museums of San Francisco, 2011.58.15
p. 4: detail of pl. 66
p. 6: detail of pl. 57
p. 8: Anthony Friedkin, contact proof sheet for *The Gay Essay* (detail), ca. 1970–1972. Gelatin silver print, 8 × 10 in. (20.3 × 25.4 cm). Collection of the artist
p. 24: detail of pl. 47
p. 30: detail of pl. 60
p. 34: detail of pl. 32
Back cover: detail of pl. 44

Yale University Press
302 Temple Street
P.O. Box 209040
New Haven, CT 06520-9040
yalebooks.com/art

Fine Arts Museums of San Francisco
de Young, Golden Gate Park
50 Hagiwara Tea Garden Drive
San Francisco, CA 94118-4502
www.famsf.org

Leslie Dutcher, Director of Publications
Laura Harger, Editor
Danica Hodge, Editor

Edited by Laura Harger
Proofread by Susan Richmond
Designed and typeset by Bob Aufuldish, Aufuldish & Warinner
Production management by The Production Department
Separations, printing, and binding by Trifolio Srl, Italy

ISBN 978-0-300-20637-1

Library of Congress Cataloging-in-Publication Data
Friedkin, Anthony, 1949–
 [Photographs. Selections]
 The gay essay / Anthony Friedkin ; [edited by] Julian Cox.
 pages cm
 Catalogue of an exhibition at the Fine Arts Museums of San Francisco of photographs by American photographer Anthony Friedkin made between 1969 and 1973.
 Includes bibliographical references.
 ISBN 978-0-300-20637-1 (hardcover : alk. paper)
1. Friedkin, Anthony, 1949—Exhibitions. 2. Street photography—California—San Francisco—Exhibitions. 3. Street photography—California—Los Angeles Region—Exhibitions. 4. Photojournalism—Exhibitions. 5. Gay community—California—History—Sources—Exhibitions. I. Cox, Julian, editor. II. Title.
 TR647.F7469 2014
 770.74'79461—dc23
 2014005925